MW00738080

Priestess
ENTREPRENEUR

Priestess ENTREPRENEUR

Simple Truths for Creating Success in your Business

CINDY MORRIS, MSW

THE BEATRICE BROWN PUBLISHING COMPANY

Copyright © 2006 by Cindy Morris

All rights reserved. No part of this book may be reproduced in any form or by any electronic or mechanical means, including information storage and retrieval systems, without permission in writing from the publisher, except by a reviewer who may quote brief passages in a review.
ISBN 0-978-6082-0-8

Cover Design and Layout created by Cyanotype Book Architects, www.cyanotype.ca

Photo of Cindy taken by Kris Urbonas in Boulder, Colorado

Logo for The Beatrice Brown Publishing Company created by Jamie Buck Stevens

WITH LOVING APPRECIATION
I dedicate this book to Rick Davidson and Marty Wallace,
truest of friends.

Acknowledgements

With special love-filled appreciation for all the flower faeries, human and otherwise, who graced the European Flower Shop, filling the shop with their joy, laughter, and love.

To my dear brother, Ken, for believing in me.

To my beloved Beatrice Brown, Airedale extraordinaire and faithful, devoted companion.

To all my precious employees…thank you for all you taught me.

To the core group of faerie girls, my very precious soul sisters…it could not have happened without you - Simone, Heidi, Sarita, Jen Jen, Kirstin, Jamie, Em and Lauren.

To Matt, a spirit so filled with the creative force ~ thank you.

To all my dear friends who were with me every step of the way.

And to Diane (did you really think I would forget you?) who laughed me through everything.

Trust yourself.
Create the kind of self that you will be happy
to live all your life.
Make the most of yourself by fanning the tiny, inner
sparks of possibility into flames of achievement.
~ GOLDA MEIR

Priestess Energy

Each of us, female and male, holds within us the essence of Priestess energy.

Priestess energy is the part of you that knows what you hold sacred, what you hold dear to your heart, what you will nurture and tend as the precious flames of your own passion. The Priestess in you desires to serve, with the purest intention of love and commitment, that which you hold sacred.

This passionate commitment is your direct connection to your Source of guidance and inspiration. Born of this commitment is personal empowerment, fueled by consciousness, awake and aware of your part in creating your own unique life experience. This is your divinely guided inspiration.

You know and access this inspirational source when you allow yourself sacred time and space to be still, to center yourself, aligning with your own connection to your divine source of wisdom. It is then that you will know how and whom to serve in what way.

WHO IS THE PRIESTESS ENTREPRENEUR?

The Priestess Entrepreneur blends the creative, vision-driven force of the entrepreneur with the powerful, intuitive essence of her connection to the Divine. When these two energies line up in one person, you have before you an unbeatable force for positive change, a business woman who runs her enterprise with calm focus, grace, clarity of intention, passion, and love. Her business is the manifestation of her deep connection and commitment

to her desire to bring forth her own dreams.

You, as an entrepreneurial spirit, have no limitations as to what you can dream up and perceive as potential. The priestess energy directs this visionary impulse to serve the greater good, guided by your own inner knowledge and the direct connection to the core of your inner being, the connection directly linked to Source energy.

As a Priestess Entrepreneur you use your intuitive sense of what is good, true, and needed in service to your passion and love, creating and living business practices that uplift and support, remaining true to your own needs and to those whom you serve.

Service is the key tenet of the Priestess Entrepreneur. You serve others by uplifting consciousness with healthy business practices. You support yourself, your staff, and your clientele to grow and expand into all that is possible, tapping into and holding fast to the innate potential bursting forth from the soul of your entrepreneurial spirit.

I am not telling you anything you don't already know, somewhere deep inside the memory of your cells. I am here to nudge you and remind you of the divine priestess you have always been and continue to be today.

Be still, be centered, know thyself, and let the magic unfold, as it must.

Did You Know?

According to the U.S. Small Business Administration, in the year 2000:

- there were 9.1 million women-owned businesses in the U.S. employing 27.5 million people.
- these businesses contributed $3.6 trillion to the economy.
- 87% of these women-owned businesses brought in annual receipts under $50,000.
- 87.8% of women-owned businesses were sole proprietorships
- 70% of the total revenues were made in the service industries.

That's an enormous number of women working incredibly hard for not a whole lot of money, in service to others, and still choosing that over working for someone else.

I am one of those women.

As Priestess Entrepreneur...so are you!

Table of Contents

Introduction

I owned and operated a retail flower shop in a busy college town in the foothills of the Rocky Mountains from 1991 to 2001. Creating, living, and breathing my business became my daily spiritual practice, my path to communing with the deepest parts of me. The challenges and triumphs of myself those years brought me to a deeper understanding of my intention in my life, my core values, and the ways in which I see and perceive my world. My business became for me my child, my family, my nemesis, my great joy, and my most profound teacher.

During the course of owning my own business, I became close friends with a handful of women who were also growing their businesses. Their stories are interwoven with my own, creating a tapestry of patterns that I watched develop during the years of our association with one another. I noticed repetitive themes presenting in our businesses that were directly correlated to what we believed about ourselves, our staff, our customers, and our commitment to our own success. Whatever we believed our business to be, either consciously or unconsciously, was exactly how we experienced it to be.

As I tend to be level-headed, practical, and always looking for the way that events in my life propel me along my spiritual path, I became the advisor, the central hub for these women. My commitment was to live my business as consciously and mindfully as possible and to utilize my

experience in business to help me to grow closer to my true self.

I wanted to learn to manage my business so that it supported the lifestyle I wished to create and not become a slave to it, to own my business and not have it own me. That was a lofty goal and one that I found to be easier said than done. I had no idea that a business could take on a life of its own and, given a chance, suck the living daylights right out of me ~ if I let it.

I came to realize that my business would only be as healthy as I was. I had to learn and implement balanced, sane, and healthy business practices in order to have a business that would sustain me and allow me to live a life worth living.

To run a business with the goal of uplifting ourselves and our world, we, as women business owners, as the Priestess Entrepreneurs that we are, need guidelines and support. *Priestess Entrepreneur* is directive, offering concrete dos and don'ts. It tells the brutal truth of the reality of owning one's own business, in funny and endearing ways. My business did not make me a billionaire ~ it provided a lifestyle that worked for me: a consistent livelihood and a wonderful safe haven of beauty and pleasure. My business taught me how to walk a conscious path, the high road of business practice. My business taught me that at day's end all I really needed to feel was content and satisfied with a job as well done as I could do it ~ not as Superwoman would have done it ~ how I could.

My wish is that the stories and insights in this book will make your life as an entrepreneur easier and more enjoyable as you work your businesses. My hopes are that these writings will shed some light on your own path and sprinkle it with some humor and compassion.

I felt compelled to write this book because every time I'd read some self-help article in one of the myriad of magazines about women in business I would cringe. Articles about superwomen drive every one of us in business stark raving mad with how successful and how incredible and how wonderful "successful" women's lives are and, for Heaven's sake, they don't even have bags under their eyes!

This book is for those of us of glorious imperfection who have birthed businesses, made them our lives as well as our livelihoods, worked brutal hours and persevered in the face of failure and paralyzing exhaustion. We who continue to show up day after day after day after day and believe, beyond a shadow of a doubt, that our business would succeed and our business would thrive and even if it didn't, it would not have been for not giving it everything we had inside.

This book is for all of us who are doing good and beautiful works in our businesses, touching people in meaningful ways, providing services to customers because it feels good to do so, providing jobs for our staff that we adopt as our family. Like sled dogs in a blizzard, we forge ahead, no matter what. Certain of our instincts, no wild winds or freezing snow could hold us back from our destiny to run, to fly, giving our all.

This book honors courageous, forward thinking women who continue to inspire me to be the most outrageous person that I can be.

I hope that I can do the same for you.

Enjoy the stories. Use the information to help you on your own way, remembering that the real heroines in business aren't usually glorified on the newsstands. The real heroines are the ones who run businesses in your neighborhood, right down the block. They show up and serve you every day because they are on their own journey, as you are on yours.

Owning your own business is not a world of glamour. Owning your own business is hard all-consuming work, commitment, and sacrifice ~ the ingredients necessary for anything worth creating. I felt it was all worth it. Here's to your business! May it be worth the effort of your love and devotion. Here's to living your business on the priestess path, bringing you the deepest fulfillment of your life ~ your conscious empowerment.

I don't know about you, but I have shopping bags under my eyes that rival those from Bloomingdale's and I've earned them!

CHAPTER
1

"You want to do WHAT?!"
FILTERING ADVICE

One

In the early spring of 1991 I made a life-altering decision. I would no longer work for anyone else. I would no longer be on someone else's time clock, at someone else's beck and call. I would no longer do my life by someone else's rules, schedules and demands. I spent that spring in a very internal process of self-discovery. It was at that time that I began to consciously connect with what I wanted for myself in my life, beginning to disengage from what I thought was wanted of me.

I was in conflict in my career and in my personal life. Not only was I having an identity crisis in my career, I was also going through a painful divorce. I know it is said that no decision is a bad one, that every decision brings you to the present moment, but I don't really believe that. Some decisions make your life easier and some decisions put you on a learning path. All too often, the learning path is the harder path. Perhaps ultimately the learning path is better, but while you're doing it, it's nothing short of hell.

AH....ENTER THE BEST FRIEND

That spring I shared a house with two roommates in a 1960's tract house by a park through which ran a beautiful stream. My days were spent walking with my two dog friends along the creek, reading every self-help book I could get my hands on, sleeping, and crying. I had a very precious girlfriend in my life at that time, Marty.

She became my co-attendee at support groups and co-creator of my

business. I call her the foremother of my flower shop business.

Marty and I met at a shop where I was teaching flower design classes. We became best friends at first sight. She began work there after she completed the design classes. We worked together at that shop for a few months until we hatched our plan to escape. Our boss was a very erratic person, chaotic and unpredictably abusive to the staff. Working there motivated us to change our situation, to move on to create a more fun and rewarding work environment for ourselves. We were looking for nothing less than fundamental changes in the way we were experiencing our lives.

> The two most important things to consider regarding advice are:
> ❧ Consider the source
> ❧ Consult with yourself

Marty had run a successful travel agency for 33 years. When we met she was in a mentoring phase of her life, wishing to impart on some lucky soul (that became me!!) all she had learned in business, as her mentor had done for her. In embarking on the flower business together, it was always clearly mine, with Marty available for full support and guidance until it felt time for her to let me fly solo. She ended up staying for 6 months after I moved into my first little shop.

As I walked away from work and a marriage, renouncing all that was that shall never be again, I spent my days roaming around looking for myself. Everyone I knew had an opinion about what I should, shouldn't, could, and couldn't do with my life.

The two most important things to consider regarding advice are:

- ❧ Consider the source
- ❧ Consult with yourself

Oftentimes unsolicited advice is meant to be helpful and to show you that the advisee cares for you, but sometimes people stick their noses into

what is absolutely not their business.

What I have discovered over the years is:

- Nobody really knows what's best for me except me
- Everybody has their own agenda

TRUST

There are certain areas of your life where it is appropriate to gather advice and use it. For instance, if you are not feeling well, you go to your health practitioner in whom you trust and believe, following their advice to improve your health. The same goes for legal advice. If you were creating a sales contract with someone or settling a divorce, legal counsel is advice well worth taking, if it comes from a lawyer you trust. And here is the operative word: trust.

It's all about the trust factor. Even if you trust the source of your advice, you need to consult with yourself and feel if the counsel is right to you.

If it does not feel right to you... don't do it!

WHAT'S THEIR AGENDA ANYWAY?

Clearly identify someone's agenda. Do they have an agenda for you? Are they projecting what they want for themselves onto you? Do they sincerely want you to succeed? Are they trying to sell you something to benefit them? Did you ask for their advice in the first place? Is the advice unsolicited?

Even when you hire legal counsel you need to make final decisions based on how the process and the outcome feel to you. No one that I know has had more unfortunate experiences with lawyers than my sister. In a very difficult divorce settlement, spanning 18 years, she has had lawyers who claim to have lost the entire file the day before the court date; she has had a lawyer who was arrested and sent to jail for drug trafficking; she has had a lawyer who, even after being given the stipulations he needed to cover in his presentation to the judge, did not cover my sister's interests, leading to a

tremendous amount of anxiety, time, and money wasted in the legal system. Even very expensive counsel and advice can lead you down a thorny path. I feel it is always best to watch over your own needs as much as you possibly can. In the long haul, you will only be left with you anyway and it is with you that you will have to settle your accounts.

What I have discovered over the years is:
~ *Nobody really knows what's best for me except me.*
~ *Everybody has their own agenda*

This is not to say that you should make important decisions for yourself in a vacuum. I have always benefited from talking out issues and scenarios with a trusted friend, family member, or therapist, supporting myself in making the most clear-headed, right decision for me. Sometimes, even after this type of process, I decide to follow through in a certain way that feels right in the moment and then later, in retrospect, doesn't feel quite right. If I have made that decision myself I have the opportunity to learn from it, identify and recognize a pattern I might want to change, or perhaps have more of an appreciation for my own eccentric personality quirks.

You would never ask a car salesman: "Do you think I should buy this car?" Of course, a salesman will want you to buy a car ~ that is his agenda. The only person who can tell you if a car purchase is right for you is you. You will be driving the car, you will be making the payments on it, and you will be paying the insurance premiums on it. The car and the purchase of it need to feel good for you, not to the salesman, and not to anyone who is "helping" you to decide.

Only you can decide what is best for you.

CONSIDERING OPTIONS

After Marty and I left the flower shop and decided to move on with our lives, and after enough down time without work, there was no question I had to get back on track and make a life for myself. I had to figure out how to bring money in to support myself and my dog and I needed to spend my days doing something that I not only could tolerate, but would actually enjoy.

Though I have an undergraduate degree in horticulture and a Masters degree in Social Work, I felt so emotionally crippled that the thought of going into some sort of professional job with benefits and dress codes was just not something I was up for, by any stretch of the imagination. My mother had been a teacher for many years and so she suggested I do that. GAK! I cannot tolerate being around a large group of kids and, feeling so incompetent at Life, how could I possibly guide young folk when I barely knew where the road was myself?

I had tried my hand at various forms of social work and flower work and I just could not bear the thought of performing for another boss. I am wildly rebellious and am really mischievous when anyone tries to confine me, limit me, or structure a system around me, unless it is all of my own doing. So it became obvious that I was going to have to create something of my own doing or it just wasn't going to work for me.

Enter all the well-meaning people in my life, alive and dead, who have an opinion on what I should do next. My mother, as I mentioned, thought teaching would be good. My father, who had passed on years before, always had suggested to each one of us kids to go into the medical field. He had always wanted to be a doctor but circumstances in his life made that impossible for him. After I received my bachelor's degree he thought I should go into phar-

If it does not feel right to you...don't do it!

29

maceuticals and use my degree for plant science research ~ perfect example of advice from projection. My father had no inkling of my capabilities, and they certainly did not lie in a lab or any kind of scientific organization, but he certainly knew what he would have liked to have done with his own life. The man loved medicine, but I did not.

Both of my brothers felt that I should pursue my social work career as I am a natural chatterer and have a huge, compassionate heart. I could not deal with the systems with which I would have to work, and the sadness.

My sister thought I should look for, and marry, a wealthy guy. My mother thought that was a great idea too. She always said that it was just as easy to fall in love with a rich guy as a poor one. As we know, this is a very popular choice, and always has been. It never rang true for me for I was always frightened that I would be held back, confined, controlled in some way unless I made my own money and my own rules. Out of this conviction to make it on my own was born my business ~ mine, all mine. Who knew the trials and challenges this conviction would bring to my life? It seemed like the easier path at the time, but how was I to know?

Only you can decide what is best for you.

I told everyone I would be doing freelance flowers out of my home (i.e., the kitchen and the garage) and I'd see where it would go from there. The standard response was: "That's nice. Can you make a living at that?" How the heck could I know? I certainly wasn't making a living at anything else, so what was the difference? I did know that I adored flowers, and also, Marty was going to do it with me. How fun?!

One brother came to visit that summer that I began my home-based business and as he viewed my old beer cooler set up in the garage (Marty's husband was in the hearing aid business at that time and traded a hearing aid for that cooler as a start-up gift for me) he could not believe that

someone would order flowers, I would provide them, and I would receive payment for them. My brother had never purchased flowers in his life, so of course he had no idea that one could actually make a living providing such a service. Being in such a vulnerable in-between place I began to doubt myself, for would not my brother want the best for me? Well, yes, but not if it was outside his frame of reference. His frame of reference was: you go to an office and you work. He was a lawyer and a law professor. Retail was just not something he could, or would, ever consider as a career choice. He could neither imagine it for himself nor for me. This is all to say that even someone who cares for you and really wants the best for you is not necessarily a person whose advice you would want to follow.

Only you know what is in your heart.

My motivating force has often been my will. I implement plans by sheer willpower and rebelliousness. I call it rebelliousness because I have found that many times I will move forward on something because someone told me I could not, and would not, be able to do it. It has been a pattern in my adult life to briskly move where I fear to tread. I don't usually take well to advice, even if I pretend to myself that I want it. Sometimes I ask for advice, knowing full well I will proceed ahead as I choose to, regardless of what anyone else might think. I feel that over the many years that I have been practicing at life I have come to be able to filter advice that is good for me and advice that is not.

FEAR-BASED ADVICE…WATCH OUT FOR THIS!

You have to be able to distinguish between advice given from fear and advice given from knowledge. Advice given from the advisee's fear will always sound like bad news couched in worry and fret. The most vociferous advice I can remember receiving came about 4 years after I had established my store. The business was bursting at the seams and I had to move to a larger space.

There was a shopping center located by the hospital that had been established in the 1950's. The neighborhood was becoming quite upscale.

People were buying up the old houses there and remodeling them. The mall already had some cool shops and some shops that had been there on the original lease. The center had been purchased by a group of twelve investors and was their dream child. They were making it into "the place to be". Diagonally across from the center was another florist shop. For some reason everyone and their mother thought that that flower shop would make it impossible for my shop to succeed, and they were going to tell me so.

The well-meaning "advice" sounded something like this: "What about the competition from the shop across the street?" "Aren't you worried that you'll be in competition from the shop across the street?" "Are you aware that there is a shop across the street?" I began to actually enjoy the exchange because when I told people where I was moving to, I could anticipate the response.

Call it bravado, call it courage, call it just brazen stupidity and not studying the market needs, I never once considered that the shop across the street would do anything but bolster my sales. It's like the car lot theory of marketing. You know how car lots are usually found together in the same area? It actually creates a desire in the consumer because not only is there so much from which to choose, but there is also the fun of comparison shopping. I was so sure of my business and what I had to offer that it never occurred to me to be concerned about what someone else was doing. I was so focused on what I was creating that it never crossed my mind to be concerned with the shop across the street except that it would offer comparison shopping, something that I felt confident would work in my favor, which it did.

> *Only you know what is in your heart.*

BIG SHOT ADVICE CAN SOMETIMES BE THE WORST KIND

I knew of a small catering and take-out place in a huge shopping center where the town's largest grocery store was located. To me, it always seemed

out of place and not at all suited to the type of clientele who shopped there. I asked the owner how they chose that spot for their business. She gave me a very complicated answer that involved a brother from California who was a marketing research specialist. He had researched retail spots around the country and this was supposedly the perfect spot. The problems that developed and brewed there finally collapsed the business. The bottom line was that the location was completely inappropriate to their type of business and they had listened to advice of a marketing specialist who had never even been to our town!

PRIESTESS PEARL OF WISDOM

A small business needs to be the fulfillment of the owner's dream. Know your dream and be willing to commit to it 100%. Regardless of what the outcome of the journey is, it is yours. Ask for advice when you feel that you need it but remember to only heed advice that feels right to you, advice that is aligned with your deepest dreams and visions for yourself. Only you know what is right for you.

CHAPTER 2

Revealing the Myth
of Unworthiness
GO FOR THE BIG DREAM

Two

As I began to work my own business out of the house I came up against my biggest obstacle...me. I thought it would be so fun and so easy to just "do my own thing". It wasn't. I had never created my own livelihood for myself; I had always worked for someone else. I had never had to make decisions of the scope and impact of the ones that lay before me every day. I had no idea how frightened I would be and how unsure I would be to move forward. Though I had exciting ideas and dreams of success I did not have any idea how to get from my kitchen, where my flowers shared space in the fridge with leftovers, to a real-live flower shop.

I came to realize that the only thing that limited me was my own belief in myself. When you work for yourself you don't have the luxury of blaming someone else if you fail but you do have the pleasure of enjoying the success when you do well. The conversations you have with yourself will be the most important ones you have. Undoubtedly as that conversation evolves you will have to face the big lie ~ the myth of your own unworthiness.

EXPOSING THE LIE

The myth of unworthiness is just that ~ a myth, a story. A myth is only as true as you feel it to be. A myth tells a story, using archetypal characters, to teach people about themselves.

Myths ask you to look at your life and see if there is something there for you to learn about yourself. Myths challenge you to ask...is that me?

The conversations you have with yourself will be the most important ones you have. Undoubtedly as that conversation evolves you will have to face the big lie – the myth of your own unworthiness.

The myth of unworthiness must be dispelled so that you may live your true life.

This core belief is the cause of all failure, all disappointment, putting the brakes on any and all forward movement. At times it seems that unworthiness is part of our genetic structure, but in truth, it is not part of our genetic structure ~ it is the veil that covers all that is our true Self. The veil removed will reveal your true divine gift, your perfect self.

You are completely worthy.

Every single thing that you have heard, digested, and incorporated that does not support your inherent worthiness is false.

You will have to face this demon head-on in order to win this battle. The feeling of unworthiness is so subliminal, so unconscious, and so all-prevailing, that it requires your constant vigil to keep it at bay. First you have to recognize it.

Believing that you are unworthy will always support your belief that you cannot have what you need.

Unworthiness, like anything else false in your life that you have come to believe as true, will present itself as true. You will think it is true, you will make it true, and you will believe it to be true, therefore to you it is true, but it is not. Every time you stop yourself from having what is rightfully yours, the belief of unworthiness convinces you that you cannot have it. Whether it be a material thing like a car that is dependable, or an emotional thing like a good friend to listen to your fears, or a mental thing like a supportive staff

to be there for extra work load, or a spiritual thing like enough private time in a relaxed state so you can actually hear yourself breathe, the unworthiness will tell you that you cannot have it.

DEMYSTIFY THE BELIEF WITH CONSCIOUSNESS

When you turn the light of consciousness onto a false belief it will fade away.

What is the light of consciousness? The light of consciousness allows you to view your life through the lens of pure Love, the same lens you look through when you look at someone you love so much you can only see how much you love them ~ like your dog or your cat or your child. Unworthiness, like all beliefs that are not of the light, vanishes when the light is shone upon them. The light that you can shine on unworthiness is the light of your awareness, your consciousness. Unworthiness cannot exist when you love yourself as you love your dog or your cat or your child. Unworthiness cannot exist in the light of your consciousness, the presence of Love.

Every time you shine the light of consciousness on unworthiness and choose a different path, you are diminishing its power over you and your decision-making process.

If you make your decisions from a mental state of unworthiness you will always make the wrong decision for yourself. I know this because I have done it, my friends in business have done it, you probably do it, and every woman you know probably does it. Making decisions from a mental state of unworthiness is running your business from the emotional wound of not loving yourself.

> *The myth of unworthiness must be dispelled so that you may live your true life.*

Any devaluation of self, by words or actions, devalues our businesses and ourselves.

FEELING RIPPED OFF

The emotional wound of unworthiness will cause you to devalue your words and your perception of what your time is worth. Business owners who do not value their time will not charge enough for it. They are always giving themselves away and then they wonder why they feel ripped off. Of course they feel ripped off; they ripped themselves off. And they have no one to blame but themselves. The rip-off is part of the unworthiness drama.

Here is what unworthiness sounds like in your head:

"How could someone possibly pay me for my time? I have to give them something concrete, to prove my worth."

You are completely worthy. Every single thing that you have heard, digested, and incorporated that does not support your inherent worthiness is false.

If you do not value your own time, no one else will. You can go to the bank with that one.

One of my greatest teachers of self-worth is my lawyer, Howard. Every time I receive a bill from him the first thing I do is laugh. All I can say is, "Wow! That guy charges by the second. He doesn't have any problem in the self-worth department. He knows what he is worth and now I know as well." Whenever my girlfriends tell me about how they once again ripped themselves off by giving their time away, all I have to say is "Howard", and they know what I mean.

I'LL JUST DO THIS FOR YOU ~ NO CHARGE

Lois is a Feng Shui consultant and interior designer. Here is an example of how she devalues her time. She drove an hour to get to a consultation in another town, gave them an hour and a half of her time to look at their place, gave tips, pointers, and suggestions, and then drove the hour back to

her home ~ all for free. That was three and a half hours of her time. At Howard's rate that would have been $700. For Lois, she spent $10 in gas, wasting all that time that she could have been working on a project that would have provided income, as those potential clients never did hire her for her services. She called me when she got home and told me that she felt really tired and kind of ripped off. I said, "Howard". She said, "Absolutely. Next time I am charging a consultation fee, and if it's out of town, I'm adding on travel time". Now she's getting it. Give that woman a massage.

IF YOU DON'T VALUE YOUR WORK ~ WHO WILL?

If you don't have the confidence to charge for your time, why would a customer have confidence in your work? You have to set the precedence for high quality work, worth what you charge. Make sure you are charging enough, so you are getting paid what you are really worth. Make sure you are being paid for all parts of the work ~ the materials and the labor. You can give freebees when you're donating in your charity contributions, but when you are charging a customer for your work, set the price that you want and let yourself receive it.

Another time I was at Lois's she was finishing up a custom-designed Italian silk cover for a love seat. Watching her create this was nothing short of magic. The woman is so talented and so clever. I asked her

Believing that you are unworthy will always support your belief that you cannot have what you need.

how much she was charging for the piece and when she told me I almost fell off my chair. "WHAT!!!!!???", I screamed. "Are you completely insane? That is less than you would pay for a polyester seat cover machine-made!." She said, "Oh, but it's so easy for me to do." "Yes", I said, "but the customer doesn't have to know how easy it is for you to do. All she knows is she wants

a custom-made slipcover to fit her oddly shaped love seat, she wants it made out of fine Italian silk and she wants it done yesterday. You have already made two trips to her house for measuring and to show her color samples!

> *Unworthiness cannot exist when you love yourself as you love your dog or cat or your child. Unworthiness cannot exist in the light of your consciousness, the presence of Love.*

How much are you making on this project?"

When I convinced Lois to calculate the time she had put into the project and the cost of the material, she had made under $10 per hour. How ridiculous. I said, "If she had ordered this piece from a catalog it would have cost ten times what you charged her and she would not have had your personal service included in that."

You've paid for what you know ~ now get paid for knowing it.

This is not at all an uncommon story for a woman in business. We so often give away our time and completely devalue our services by not calculating what we want our time to be worth. It's frightening.

Let us not forget the time it took you to learn all that you have learned so that you are able to offer the service that you now offer with such ease and know-how. Howard charges his rate because he learned the value of his time and the value of his knowledge. He paid for a lot of that in his law school and accounting education. You have paid too.

When a potential customer called my astrologer friend for a reading the customer asked how long she spends before the consultation studying the chart. The astrologer responded that she doesn't spend any time at all; she does the interpretation on the spot. I suggested that she should have said: "30 years", as that's how long she has been studying and learning astrology! Her readings are as fine and accurate as they are because they

are a result of all those years of preparation!

If you offer a professional service for which you have not attended a degreed school program does not negate all the time and energy you have put into learning your skill.

You decide the value of your work. The people who recognize and appreciate your value will service your business.

PRICING WEDDINGS AT MY SHOP

I had a very busy and lucrative wedding business at my shop. I also think I was the highest priced wedding provider in town, or close to it. I never had a problem with that because I felt that the quality and service my shop offered was worth it. I felt that I was worth it, and my staff was worth it. I

If you make your decisions from a mental state of unworthiness you will always make the wrong decision for yourself.

had confidence in our creations and our performance. I always compared my shop with the finest restaurant in town. You know you'd be paying a lot to eat there, but the food and the experience would be worth every penny. I felt that way about our work, worth every penny.

For some people we were too pricey, and that was fine with me. The wedding business that we contracted was lucrative and was worth my time. Brides who chose to work with me got the benefit of my 25 years of hands-on experience. We charged a fee for our wedding consultations, which could then be applied to their order if they chose to use our shop. These meetings ran from one to two hours. Not only did I have to pay an experienced employee to interview the bride and her entourage, I could not be utilizing that employee to do other work during the time of that consultation. We put that fee towards their wedding bill if they chose to use our shop, and if

they chose to go elsewhere we were being paid for our time. If a customer did not feel comfortable paying for the consultation then I really did not want them as a customer for I knew that they did not value my time ~ and I did.

With the overhead I had to cover each month I quickly learned that I could not be giving my work and my time away for free.

CONFUSED PRIORITIES ~ GIVING YOURSELF AWAY

Lois was in the process of creating a web site and expanding her business. In the transition time of business-building she was in a very tight financial position. Though she no longer wanted to do interior design work, she needed to do it for the cash flow. Since she had always undercharged for her design services, she still was reticent to charge appropriately for her time.

A client contracted her to do her home in a ski resort town about five hours from where Lois lives. In the midst of all kinds of legal and patent deadlines that she needed to make, the client called Lois and told her she needed her to come up to her house and complete the accessorizing as the main work was already completed. Lois felt that she could not turn the job down because she needed the money and the woman had become a friend. Be cautious when making friends of your clients as this can cause a lot of confusion in the "worth" department. Lois did not charge enough for the trip and felt ripped off even before she left on the trip.

> *Any devaluation of self, by words or actions, devalues our businesses and ourselves.*

She did not charge for her travel time (which turned out to be ten hours of winter mountain driving) or for gas reimbursement. She could have, and should have, charged for mileage to compensate for some of the driving

expenses but did not. Because Lois was working from a belief of her own unworthiness, she gave away many hours of her precious time. It would have been time better spent working on her promotions and her web site, with the goal of increasing her chances of bringing in future business in the part of her business she was wanting to focus.

UNWORTHINESS IS A LEARNED BEHAVIOR

Unworthiness is a learned condition; you are not born with it, though it might feel like you were. You literally have to unlearn the belief of your unworthiness when you grow up, as part of your commitment to living your true self. Your true self weeps every time you make a choice from your unworthiness. Your true self knows that you are not making conscious, aware choices, but are functioning on autopilot from what was taught to you by other people who were living from their unworthiness.

UNWORTHINESS IS PASSED THROUGH THE MOTHER LINEAGE

Most of us learned our unworthiness from our mothers, who learned it from their mothers and on and on back through the lineage. Much of this information is passed down to us unconsciously. Our mothers teach us ways to be in the world by mirroring to us their own behaviors. Though our mothers might want for their daughters more than they had for themselves in their life experiences, their words will not affect us as much as their behaviors.

The emotional wound of unworthiness will cause you to devalue your words and your perception of what your time is worth.

Though the words we hear from our mothers are so vital to our perceptions of ourselves, even more than the words is how we

perceive our parents to feel about themselves.

Happy mommies, happy daughters. Unhappy, devalued mommies, unhappy, devalued daughters.

THE WORKHORSE

Chances are that if you own your business you will have the workhorse personality. The workhorse personality is just that ~ working like a Clydesdale in the potato fields of Ireland. You get the picture. The workhorse person undoubtedly learned this work style from her Mother figure who also was a workhorse.

To be a workhorse has its benefits ~ like the ability to pull off unbelievable feats of production and follow-through that would boggle any normal person's mind. No doubt about it, the workhorse can do the unimaginable in workload and performance. The problem with being a workhorse is that most workhorse women have zero sense of appropriate delegation and they do not give themselves time to rest and recuperate.

Why do they do this? Because they do not believe that they deserve it and they forget that they really aren't horses – they are human women.

If you do not value your own time, no one else will.

You'll hear a workhorse spout off the following rationalizations for their compulsive workaholic nature:

"I forgot to eat to today; I was so busy working."

"I don't have time to exercise."

"I don't have time to relax. The work has to be done and I have to do it."

"No one can do this work as well as I can. It's easier if I just do it myself (along with everything else I have to do that no one else can do)".

"I don't have time to have any fun – there's work to be done".

Do any of these lines sound familiar?

LOIS

My favorite workhorse story is again of Lois. For her birthday Lois received two gift certificates for body pampering and relaxing at the local spa. She also had over $1000 worth in trade with a local chiropractor for work she had done in his office.

I called Lois one day to find her weeping from exhaustion and frustration. She said her body was aching from working so hard and worrying. She said her back and hips were hurting terribly. I asked her if she had ever used her gift certificates at the spa or been to the chiropractor to use her trade. Sheepishly she admitted that she had not even thought about "treating" herself. Taking care of and tending of one's body are hardly "treats" ~ they are a necessity.

You've paid for what you know ~ now get paid for knowing it.

Do you take better care of your car than of your body?

Your body is your vehicle to maneuver you through life. If you do not care and tend for your body, what will you drive?

Lois's mom was emotionally unavailable for Lois. She had been married to an emotionally shut down man and was depressed for most of her married life. She raised Lois and her four siblings without adequate emotional or financial support from her husband. Lois remembers her as sad and always working ~ the endless drone of housework ~ cooking, cleaning, and laundry. She was more like a maid than a mother to Lois. She died in her early 50's of kidney cancer.

Lois married very young and had two children. Her husband was in a construction accident just two years into their marriage, when her boy was three and her daughter a newborn. He went through a series of back surgeries and was in chronic pain for the next twenty years of their marriage.

Though he came from a wealthy family, the parents never helped them out. It fell upon Lois to be the breadwinner for the family, while also doing the "woman's" work at home.

For 20 years she ran herself ragged, working herself into exhaustion. She finally ended the marriage. The divorce only propelled her into more of a frenzy of work. She convinced herself that if she worked harder and harder and harder she would "succeed". She always said, "I'm paddling as fast as I can", to which I would respond, "Where are you going?" At 48 she was showing pre-diabetic health symptoms and depression. She was completely unrealistic about what she was capable of doing, overextending herself, both physically and emotionally, and never making herself a priority in her own life.

MEPHISTA

Mephista is a spiritual counselor; she works out of her home. She is married and has a teenaged daughter. She sees clients all day, either in person or on the phone. Being an over giver, she will talk to nearly anyone who needs her, regardless of the time of day or that she might rather be with her family, or with herself.

She works 8 to 10 hours a day and then cleans and cooks in a whirlwind of frantic energy, making sure there are perfectly healthy and balanced meals for the family ~ every day, every meal. Her daughter needs to be driven around town to all her various activities.

Mephista is always concerned that

> You decide the value of your work. The people who recognize and appreciate your value will service your business.

she is not doing enough and is not being a good enough mom to her daughter. She has a lot of self-doubt, pushing herself to perform superhuman

tasks. Mephista doesn't get to bed until midnight most nights and she's up again at 6a.m. to start all over again. A few weeks ago she found herself in the parking lot of a local strip mall in her car with her daughter. Her heart was racing; she was in a full sweat. She was having a panic/anxiety attack. She couldn't drive. She called one of her friends to come get her and take her and her daughter home.

> Happy mommies, happy daughters. Unhappy, devalued mommies, unhappy, devalued daughters.

Mephista recalls her mom as a woman who worked 40 hours a week, coming home at the end of each day and like a "white whirlwind" cooking and cleaning for 3 daughters and a husband. Mephista says she remembers at what insane speed her mother would accomplish everything ~ and then collapse.

VELDA

Velda is the queen of all workhorses, the prize Clydesdale. Her stamina, stubbornness, and ability to plod on are nothing short of miraculous. She has so completely dedicated herself to her business that she has effectively married it, to the exclusion of any semblance of a normal emotional life.

Velda is a caterer, a one-woman show that would rival Barnum and Bailey's. For ten years she has been the office person, the marketing person, and the chef. She also does all the training, vehicle maintenance, buying, and schmoozing. Occasionally she will hire other people to do various parts of the business, but she invariably ends up firing them or they quit. She has a really difficult time giving up any type of control to an employee.

What Velda does is incomprehensible to the normal person. Until this year she washed the floors herself, after everything else was done, usually after midnight. She hated to have to come in to work to a dirty floor ~ and she would be back in at 4:30 a.m. to prepare breakfasts for some local business event.

This year was the first time it dawned on her that she could hire someone else to wash the floor. She still questions if it's worth the money, after all "I can just as well do it myself".

Velda has no social life, except as it involves the marketing of her catering services. She has no boyfriend and no emotional life outside the business. She has one best friend in town, and a few friends out of town, all of whom she has telephone relationships with during the few moments that she lets herself be away from the kitchen.

Velda's primary activities have become worrying and whining. She starts worrying as soon as she awakens (always before 6 a.m.). She has classic symptoms of stress – grinding of the teeth (this year alone that cost her $3000., not to mention unbearable pain and discomfort), hair falling out, explosive emotional responses, depression, eating disorder, (addicted to sugar), poor digestion, and problems sleeping. When she is not worrying in private she is complaining to anyone who will listen.

We call Velda's mother the queen martyr. It is from this master of martyrdom Velda has learned so well. Velda's mom was married for nearly

Do you take better care of your car than of your body?

40 years to a verbally abusive, alcoholic man. She was so enraged for so many years, but was unable to express herself, that she filtered her unexpressed emotions into perfectionism and cooking, specifically baking. To this day, at age 76 and widowed for 20 years, Velda's mom will have cupboards full of freshly baked goods. She likes things exactly the way she likes them. She is also a compulsive shopper (she has five closets in her home all filled with clothes that still have their tags on them).

Velda's mom will never let anyone do anything nice for her, like take her out to eat, or splurge on her in any way. I visited with her at her home and stayed there for a few days. I wanted to take her out for lunch. She brought me to a deli/buffet and ordered a cup of soup and crackers. She refused to

let me do anything for her. She does not like anyone to fuss over her in any way, which has created some scary health dramas for her. She has digestion problems, high blood pressure, and is highly allergic to some substances, causing her tongue to swell dangerously. She resists going for help until it becomes an emergency situation. Sounds just like Velda.

> *The number one problem, and stumbling block, for women in business is the inability to speak what they know to be the truth.*

ME

My mother was a remedial reading teacher at an inner city school in the Bronx. While I was a teenager she was so exhausted she only had time to work, cook dinner, and then collapse on the couch, where she fell asleep every night. On the weekends she would clean the closets.

I worked myself so hard at the shop I would come home, eat, collapse on the couch and often fall asleep there. I had no time for a healthy relationship or healthy friendships, or time to do things that might have been fun. I was not married, and did not have to take care of a family, and I still worked myself to exhaustion. I took on the staff of my shop as my family, overextending to them and caring for them in ways that stretched me beyond my capabilities.

I felt that collapsing into exhaustion was normal and expected behavior.

I often would find myself making concessions and sacrifices for my employees, putting their needs and concerns above mine or those of the business. I would find myself getting confused as to what were appropriate concessions and what were not. I would be the one to pick up any slack, never expecting or asking the employees to stretch their own limits, creating more work and more exhaustion for myself.

Weekend fun was cleaning my closets, doing laundry compulsively, reading, and taking extra long naps. Going out and actually enjoying the spectacular place that I lived was not possible. I only had the energy to recuperate from the week and psyche myself up for the week to come.

> *R*unning your own business, where you are 100% responsible for everything that does or does not happen in your world, it is essential that you value yourself enough to create and maintain a viable working environment. You must be able to speak your beliefs and live your beliefs so you are able to create a business that is a true reflection of you.

For the first year I was in my larger shop at the strip mall I was open on Sundays. I created a situation where I never had any time off at all. I called off Sunday hours by year two at that location. I needed more time to sleep.

WE DON'T EVEN LISTEN TO OURSELVES

Not speaking our truth is a much more subtle, and crippling, practice than devaluing our time. It is our voice that is muted. We end up not feeling heard, that we are not being taken seriously.

Do you listen to yourself? Do you mute your own voice to your own self?

The number one problem, and stumbling block, for women in business is the inability to speak what they know to be the truth. If you cannot speak what you know to be true you are unable to assert your own power, even with yourself.

Everyone has the right to speak her truth, especially to herself. We do not have the luxury to be quiet anymore. We must release all judgments placed upon us by ourselves and others and commit to identifying and speaking our own truth, our own perception of reality.

We do not have the time and the luxury of succumbing to the fear of being judged and misunderstood. We cannot let the fears that we have internalized from our life experiences to paralyze us into muteness. It begins with the tiny whispers we allow ourselves to tell to ourselves. Slowly those whispers become hushed murmurings, and before we know it, the murmurings become outspoken words and we are speaking our truths.

In running your own business, where you are 100% responsible for everything that does or does not happen in your world, it is essential that you value yourself enough to create and maintain a viable working environment. You must be able to speak your beliefs and live your beliefs so you are able to create a business that is a true reflection of you.

If you do not value your time and charge appropriately for it you will fail in a financial sense. If you do not value and respect how you think, honoring your needs and values, you will fail in an even more important way ~ you will fail to be true to yourself. Then whose business is it anyway?

SIFTING OUT THE GOOD FROM THE BAD

The patterns of behavior that we inherit from our moms are a small part of the total picture of what we got from them. Of course we also inherit the good qualities, like courage and strength, conviction and passion. The trick is to separate the gifts that serve our highest good from the curses that fill us with doubt and distrust of ourselves. It is the discernment of these gifts that your business will bring up for you – every day, in every way.

Commit to disarming the myth of unworthiness.

There are a myriad of books and articles on the media's affect on our images of our own self-worth. There are also many readings on how our mothers affect our lives. However we learned, and took on, the myth of

unworthiness, we have to be committed to unlearning it. What matters is how to come into our power, how to dissolve the myth of unworthiness and proceed ahead in power and truthfulness, lighting the way to our own sanity. It is through the disassembling of the myth of unworthiness that we step onto the path of conscious empowerment, becoming the world healers we are each meant to be, one small business at a time.

PRIESTESS PEARL OF WISDOM

When you live a certain reality and every one around you lives that reality and you are told from day one, subliminally and overtly, that this is your reality and it is the only one that exists ~ you believe it. As you grow and move about in the world you can see for yourself if these realities are true or if they were just the realities of those with whom you have been consorting. There are many realities in this world. When you hear someone say "Well, that's just the way it is" what they are really saying is "That is how I experience reality".

> Commit to disarming the myth of unworthiness.

Choose to experience your life through your own perception of reality. Then you don't have anyone to blame, or congratulate, but yourself. It's all yours ~ your life, your business, and your experience of it.

Owning your own business offers a powerful opportunity to work on

valuing yourself. Everyone will push you to your limit ~ your staff, your customers, and you. If it all comes crashing down around you, you have no one to blame but yourself. You now know what the issue is ~ your feelings of unworthiness ~ the big lie. If you choose not to address the core issue ~ that is your own doing. If you do address your issues of unworthiness in a conscious way, focusing on how changing your perception of yourself will change your entire experience of your world, you will be giving yourself the greatest gift ~ the gift of living your highest life, free of what others believe you to be, true to the real, empowered you.

> *Choose to experience your life through your own perception of reality.*

The myth of unworthiness is just that ~ a myth. It is not true; it is a story which gets you to look at your own life. So look. And make a good choice for yourself. Unveil the lie that you are not worthy and move on to light the world with your own truth of your convictions. Live your life in the truth. Nobody else is going to do it for you.

Now repeat after me:

"I am worthy of having the life I envision for myself."

Very good!!!

CHAPTER 3

Finding a space ~
UH, OH... COMMITMENT

Three

Many a business is birthed at home. In the kitchen. In the garage. The basement. A closet. Any space will do that can hold the seeds of your precious dream of being your own boss.

I began my flower business in the kitchen, garage, and basement of the tract home I moved to when I was divorcing my husband. I had two patient and forgiving roommates. When my flowers took over space in the refrigerator, they graciously moved their beer to the snowdrift in the back yard. When I moved a beverage cooler into the garage and set up shop out there, they graciously parked in the driveway. When I took over the basement with my dried flowers and tables to conduct flower arranging classes they stayed upstairs. Bless their hearts!

As my business was in the fresh, new stage of just being born and considering I got zilch from my divorce, I had no choice but to work from home.

From both the logistical and financial perspective, when you first start your business, home is the perfect place to begin. It's affordable, it's convenient, and if you choose to not move forward once you have begun, nothing too large has been lost.

Until she opened a commercial kitchen, Velda catered out of every house she ever lived in, transforming the garage into storage and the kitchen into production space.

Lois ran her interior design business from her basement for years. She

never moved to a commercial space because working from home suited her and her business just fine. Lois did all her consultation work at the customer's house, bringing samples with her on site. She did the sewing and ordering from home.

A home-based business has many benefits, the primary one being that you keep your overhead to a minimum because you're living there.

The downside of having your business at home, and it is a big downside, is that you can never get away from it.

It is always there, calling, beckoning, whining for your undivided attention. Working from home is terrible for a workaholic type person. You never can get away from it. You can never relax as there is ALWAYS something that needs to be done ~ always!

Some businesses work well as home-based businesses. You have to discern for yourself if you and your business are best suited for

> The downside of having your business at home, and it is a big downside, is that you can never get away from it.

home or if you require space separate and away from home. For me, I needed to completely separate home from business as I found myself falling into the trap of working all the time, just because it was there.

Not only did I want to be in a more visible commercial space, I knew that I did not want flower-arranging students coming to my house any more. The space was not conducive to teaching as there was not enough light and the room was in the basement, requiring me to haul everything up and down two flights of steps. I knew it was an imposition on my roommates, having people tromp through the house on Saturday mornings and in the evenings as well. If I wished to continue to teach and do occasional floral events I had to make a change.

The first thing that happens when you decide to move into a commercial

space is excitement. The "what ifs?" are usually full of all the possibilities that more exposure and becoming a legitimate, visible business will bring to you. Then panic sets in. Where will I find a space? How can I afford to pay overhead when I barely have a business now? Will I have to have employees? How do I do this??!!! Where do I begin?

THE BUSINESS PLAN ~ A FINE AND NECESSARY MAP

Begin as you would any well-thought out journey, for the growth of your business is like a magic journey.

The journey begins with a map. The map for a business is called a business plan.

Your business plan is the map to get you from your home to your new commercial space, helping you to see what it is you need to bring with you on your trip, what to expect on the way and when you get there. The business plan helps you to clearly see all that is expected of you and all that you will be expecting of yourself. A business plan is a must if you are to invite investors to back you. They also want to see what your journey is to look like.

We all know how journeys go. You make plans for one thing and something else happens. In business nothing ever goes according to plan, but you need to have a plan from which things can mutate. You have to head towards something as consciously and prepared as possible, allowing yourself to be open and flexible to opportunities.

Do a little research on what is realistically expected of you in your business plan.

The journey begins with a map. The map for a business is called a business plan.

My first business plan was 4 pages long. When I moved to the big shop it was 7 pages long. When Lois was looking to grow her business into an

international opportunity, requiring an investment of a million dollars, her business plan was like a small book.

Your business plan will reflect, in scope and need, exactly where you are in your mind about your business and what you foresee for your short-term and long-term growth.

I promise you that your perceptions about your business will change over time. Your visions are not set in stone. The business plan is there to provide guidelines and a general map. Detours and side trips are not only recommended, they will happen no matter how carefully you plan. Sometimes the unexpected detour will open up opportunities for you that you had not imagined.

Stay open and flexible, within the context of a workable structure, in your basic business plan.

Now get help! Find support for yourself at your local Chamber of Commerce or community college. Look for a class to teach you how to create a business plan. Ask other women in business as to who helped them put their plan together. Imagine you are planning a trip to a very exotic place, like the Amazon. You don't just hop on a plane and go. You do research. You talk to other people who have been there. You gather information as to what to bring and what to expect. That way you have the best possible trip. You go as prepared as you possibly can. It's the same for business, your exotic and exciting journey to your own empowerment.

> Gather information, go prepared, and be ready for anything!!

Gather information, go prepared, and be ready for anything!!

COMMITMENT IS ABOUT SHOWING UP ~
SHOWING UP LEADS TO SUCCESS

The real gift of creating and working a business plan is to challenge you on your level of commitment to your business. As you write down your dreams, visions, and goals, you will come up against any resistance to commitment you might be harboring, perhaps even unbeknownst to yourself. When you face the reality of what your overhead will be and what your hours will need to be to fulfill your obligation to your customers you will know your level of your commitment. Your level of commitment is the key to your success.

Much of business success is about showing up. A powerful role model for me when I opened my little shop was Ginia, the woman who owned the dressmaking shop in the store in front of mine. She had been in business for over *Your level of commitment is the key to your success.* ten years. In that time I watched her business grow and change, expand and blossom in interesting ways. She went from being a dressmaker, sewing in her shop, which was always her primary vocation, to offering buttons and select high end fabrics for retail sale. After five years, with retail space rent skyrocketing in our town, she shared her space with a local photographer. Her shop became an art gallery/display place for her creations. She sewed off-premises and used her retail space just for sales. When I asked her what her secret to her success was she said, "Success is about showing up every day, no matter what changes are coming down the pike for you. You go with the changes; you just keep swimming, every day. You commit to your work."

Confronting your own level of commitment will become evident as you start looking at the reality of finding a space to conduct your business. As in any part of doing business, brutal honesty is required of you. Fear will come up. Fear is a natural response to the unknown. A little healthy fear

is good, requiring of you to gather information before you plunge ahead into what feels like uncharted territory. You need to discern if your fears of moving forward are realistic and valid or are they just the smokescreen you are erecting to prevent you from expanding into your success. Only you will know this for yourself. Be willing to ask yourself these questions and be open to the true answers.

Be open to what is true and right for you.

Perhaps as you develop your business plan you realize that the timing is not right, that perhaps with all that is happening in your life on a personal level, a postponement of expansion is appropriate. Or perhaps you will realize that it is indeed time to grow and you are chomping at the bit to get things going. Listen to, respect, and follow messages from yourself.

If you feel you are ready to expand to a space outside your home, you have your business plan in place, and you are committed to receiving the care and support you are needing (remember: You NEVER have to do this journey on your own…help is just a phone call away!) then finalize that business plan and go find your space!!

A commercial realtor found my space for me. I told him what my needs were and the feeling I was trying to create in my business. He found the little alley store for me in a few weeks. I signed the lease in August and moved into the space in September of 1991. The first time I had to write the rent check for $750 I felt like I was going to throw up. I had never paid such rent before, either to live or to work. When I finally sold my business ten years later, I was writing rent checks for nearly $4000 a month, hardly even blinking an eye while doing it!

WATCH SOMEONE ELSE DO IT ~ CHOOSE A GOOD ROLE MODEL

Velda sat in my flower shop in the alley for 6 months before she felt she was ready to commit to opening a commercial kitchen. She was terrified of the overhead and the amount of business she would need to manage in

order to cover monthly expenses should she decide to stop catering out of her home. She watched me open my little shop, show up every day, move through my adjustments ~ show up, and grow up. She decided she could do it too. So she did. She has had a successful catering business for 12 years now, servicing large, lucrative events that she could have never tackled from home. She has created an excellent livelihood for herself.

PRIESTESS PEARL OF WISDOM

Choosing to open a commercial space from which to operate your business will push you to examine your commitment to your business and the level to which you are choosing to grow and expand.

Creating a business plan, with the help and support of other business people, will uncover for you your level of commitment and readiness to secure a commercial space. You will be able to see a general map of your journey to growth and blossoming, and you will also be able to see what type of financial investment you will need to make your move viable.

As in everything in business, the more honest and realistic you are with yourself as to what feels good and right and true for you, the better equipped you

> *Listen to, respect, and follow messages from yourself.*

will be to make the right decision for you and your business.

Grow into change, expand at your own rate, and enjoy the journey, after all...it's yours!

CHAPTER 4

THE BLISS OF
BEING ORGANIZED

Four

*E*ach of us has a particular way that we organize our lives, from our work life to our relationships.

You will organize your business the way you organize your life.

This could be good or bad, depending on what the needs of your business are and if your style serves the needs of the business. Though you may have created your business and continue to nurture and grow it, your business is an entity unto itself with its own organizational demands. If your organizational style does not conform to the needs of your business you need to either modify your style to accommodate your business's unique needs or hire someone to do it for you.

The Priestess Entrepreneur is committed to being scrupulously honest and forthcoming with herself on what her needs and the needs of the business truly are so that she is able to get them all met by the appropriate person or persons, which often is not herself.

WHAT IS YOUR ORGANIZATIONAL STYLE? ADMIT IT THEN WORK WITH IT, NOT AGAINST IT.

My organizational style is nothing short of frightening. I am the worst kind of person when it comes to organization in that I think I am organized, but I am not. I will get into a frenzy of organization and put everything into what I think is order and then the next day I will try to find something and I cannot remember how I chose to organize things just the day before. I know

there was some mystical way that I was thinking that would have created more order and sense to my papers, files and such, but for the life of me I cannot remember what that line of thinking was.

You should see my kitchen cabinets. What with my ungainly collection of Victorian teacups and mismatched saucers, my hodgepodge of assorted plastic storage containers, and random food items in jars with no names, it is no surprise that I was challenged to keep my workplace organized.

Periodically I go through my file cabinet and reorganize my papers and, for that day, my filing makes sense to me. The thing that has helped me the most in the organization of my papers is to admit to myself my delusion that I think I am organized. This

> *You will organize your business the way you organize your life.*

way I can no longer fool myself into believing that I have it all together, which I do not. I no longer chastise myself when I try to locate papers that I am sure I put in the most obvious, most logical place, which I can only hope was not the trash can.

My business helped me to admit this delusion I have about myself and my organizational prowess. The needs of the business forced me to reach for help, which I did, fortunately before the fire department had to be called in to get me to discard some of my accumulated boxes full of papers.

DELEGATION ~ IT'S NOT JUST A WORD, IT'S A LIFESAVER

A very important, and oftentimes difficult, thing for a businesswoman to do is to admit that she does not do something perfectly, or that she even wants to do certain things and that really someone else would be much better chosen to do it.

I have never understood why some friends of mine feel that they ab-

solutely must change their own tires on their car, should they have a flat. That's what cell phones, AAA, and car people are for. I have never been of the school of thought that in order for me to be a woman of power and substance I need to know how to do and perform every task required in the maintenance of my life. What I do need to be able to do is to accurately assess what I am able to do and what I am not able to do I hire other people to do for me. I was unable to organize my office. I needed help.

ORGANIZING THE ORGANIZATION ~ WHAT TYPES OF ORGANIZING DOES YOUR BUSINESS REQUIRE?

My flower shop business was the type of business that required many different types and levels of organization. There was the organization you could see, which was the display for the customers. There was the organization of the back-up supply of product, which lived in the back cooler and in the workroom. There was the organization of tools, supplies, and all the parts of creating that we used to make what we sold. And then there was the paperwork. All these parts had to work fluidly or there was a glitch in the system and work became a hassle, not a joy.

I could not organize my business in the chaotic, playful way I ran my kitchen at home, though I did try to do just that for the first few years of its life. That led to endless nail biting and hair ripping, my manic acts of stress and frustration.

My business needed to appear to be magical in the presentation to the customer. Behind the scenes I had to make it work, practically and realistically. In order to do this I had to admit to myself what I could and could not do, what I needed someone to teach me to do, and what I needed someone else other than myself to do.

GETTING THE RIGHT HELP

The paperwork was my biggest organizational challenge and also the part of the business I felt I wanted and needed to do myself. I wanted to do the

numbers and keep tight reigns over expenditures and income, as that was the pulse of the business. I was sorely lacking in the aptitude to do this as the business required. In order to make good, sound micro and macro management decisions I had to know how much money was coming in and how much money was going out on a daily, monthly, quarterly, and yearly basis. Though I knew that I needed to have a firm grasp on the numbers my business generated, I was poorly equipped to tackle them without having to solicit professional help.

Considering my background in horticulture and Social Work the economics of my business, and how to organize my paperwork, eluded me completely. My persistent belief in some magic flow of the finances held me back for a long time from getting the help I needed. In my distorted vision I felt that if I did not have a complete handle on the money situation it would miraculously all end up in my favor in the end. This is thinking based on the avoidance method of organization: "If I don't look at it ~ it isn't really there." I call this the "ostrich head in the sand" form of organization, which does not work. Ever.

I solicited help from my bookkeeper, my accountant, and my Feng Shui Consultant in order to create a financial organizational system that would work efficiently for me while still maintaining enough magic that I would actually want to keep working the system.

A system only works if you use it.

It's like using a diaphragm as a birth control ~ it doesn't work if it's in the drawer while you're on the bed. This is why it is so important to develop a system that you will actually use!

Enter Lois the Feng Shui machine, organizer and dispeller of chaos, par excellence. She came into my space making recommendations on how to structure the space and all that was in it to create the most harmonious, and prosperous flow. Lois first came into my shop to help me increase incoming business and improve the general flow of things. She almost passed out when she saw my office. My "organization" system was at an all time height

of madness. Boxes were everywhere, papers strewn in and out of boxes, the desk piled high with who knew what ~ invoices, bills, memos, love notes. You name it, it was stuffed to bursting into a tiny back corner of the shop.

THE OFFICE AREA

The first thing Lois had me do was to get my office in order. I should clarify that by saying that the office was not a separate space, per se. I had to create an office corner in a part of the open-air store. I made the office desk area off-limits to my staff, so that it became my private sanctuary, undisturbed by anyone else. I placed a tri-fold screen in front of the desk. The panels were made of soft ivory lace. That way I could see through to what was happening in my shop and I also had privacy for myself. I made the office into a space in which I actually enjoyed being.

Lois instructed me to separate the paperwork by year, and then within that year, by subject matter. In each box were placed monthly statements, bookkeeping information, invoices paid, payroll information, incoming and outgoing wire orders, daily orders, all organized by month and by subject. Each year was then put into its own giant plastic tub, which was then labeled. I can hardly express the joy and gratification I had in filling each one of those tubs with the appropriate papers, labeling each tub, and hauling those tubs up onto the storage space above the bathroom. When I got all that done, my floor space was relatively clean and I could begin on the mess of the "now".

A system only works if you use it.

Everything that was "now" referred to all unanswered correspondence, all bills to be paid, any papers needing to be forwarded to my bookkeeper, basically everything that needed to be dealt with, no ifs, ands, or buts. We created a system of baskets each of which I adorned with beautiful hand-lettered labels placed on a fabulous shelving hutch. I bought the hutch

at the unpainted furniture store, choosing non-toxic milk paint in a deep, warm rosy red. The hutch would occupy a large area of the relationship corner of the shop, whose colors, according to Feng Shui principles, needed to be red, pink, and white.

THE DESK AREA

I bought my desk at a used furniture store. It was large and spacious. I alternately felt like I was manning the helm of a ship or playing a large floating piano. I had one of my staff, a master at painting and enlivening old furniture, paint and distress the desk a milky white with a pink under base, flecked with gold. I put fun gold knobs that were eggplants and pears on the tiny drawers facing me at eye level so when I sat at my desk it always felt fun to me. I was given an old-fashioned banker's lamp with a green glass shade. I loved that thing. Sometimes I pictured myself as a character in a Dickens novel or as a 1940's bookie. It was fun. Anything that made the desk and the work it represented fun was crucial for me. If it did not feel like fun I would find any excuse not to be at that desk. If the office area had any feeling of industrial, or high tech, or grey at all, I'd be out of there.

The desk was placed such that I faced the front of the shop. That way I could see everything and be in the position of power, which if you're running the show, you had better be. If you are not sitting in the driver's seat of the bus, who is driving? And if you're not driving the bus, then why are you paying for it and taking on all the worry?

I had to train myself to sit at that desk, commit to, and actually do the system we created. Every day I would go through the mail and any invoices that came in, filing them into their appropriate beautifully labeled baskets. I had to play a little game with myself to keep it going when I first began. I convinced myself that all the sorting and filing was so that the desk area would remain pretty. Since it was the relationship corner, if I kept it all just lovely, relationships among my staff would flourish and my love life would be excellent as well.

I made a commitment to myself to leave the desktop clear when I left to go home each night. That was challenging at first, but as I got the hang of it, and got used to arriving in to work each morning to a clean desk, fresh and ready for a new day ~ it was something worth doing.

Periodically during the day I would go to the desk, work on some paperwork, perhaps while I was also on the phone. Being a multitask person, if I am not doing at least three things at a time, I am bored. For me, I liked to talk on the phone and do paperwork at the same time. That left more time to play with flowers, which is what I truly enjoyed doing, and why I had created the shop in the first place.

For you naturally organized types this office organizational process might sound unimpressive. To me it was likely being able to breathe for the first time since I got that business going in 1991; it was now 1995 ~ a long time to be buried under that mess of disorganization.

Because I was so unwilling to admit that I was a terrible organizer of my "stuff" I suffered in that chaos for all those years. Every time I would head to the back corner of that store, I could feel the panic rise as I knew that mess of papers would be staring at me and probably would have grown from the day before, as anything you are avoiding dealing with is want to do.

Procrastination is a deadly virus of the self- employed.

TASK DELEGATION ~
ONCE YOU DELEGATE YOU'LL NEVER
DO IT YOURSELF AGAIN

Procrastination is a deadly virus of the self- employed.

As business owner you don't have anybody telling you what needs to be done and when you need to do it. You just know that everything needs to be done and you're the one who is either going to have to do it or you will have to find someone else to do it. How and when you will do it is something

you will have to figure out, and only you can do that. This is where task and time management become crucial allies and also where you implement the all powerful tool of delegation.

I learned to become the master of delegation. As I so desperately needed my quiet time away from the shop to regroup and recoup my energy, I learned that the more efficiently executed were the chores and must-be-dones, the more time there was to relax and watch British dramas. My master plan was to create as much relaxation time as possible. The only way to do that was to economize jobs that needed to be done so as to maximize the time available for slothing about.

> *A Priestess Entrepreneur is completely comfortable stating what she chooses not to do, hiring the right person to do that part of the job.*

I am a Mary Poppins (my idol) of task-oriented efficiency when there's work to be done so that I can have as much time off as is humanly possible when the job is complete. I will plan and prioritize a project for weeks prior to its implementation. I will map it out like a military leader planning a siege. I will think of, and anticipate, anything and everything that would affect the project, and make provisions for it. I will get up at 4:30 in the morning, get everything organized and pumping for a project, and then do it, so that I have the entire afternoon to read and nap and do nothing.

> *It is perfectly fine to be the visionary, and not the implementer.*

If you are not a good time and project manager, and you do not enjoy

doing this part of the work ~ hire someone else to do it. Don't make believe you can, and will do it, when you know you won't, and set yourself up for disaster.

A Priestess Entrepreneur is completely comfortable stating what she chooses not to do, hiring the right person to do that part of the job.

THE POWER OF DELEGATION AND COLLABORATIVE CO-CREATING

It is perfectly fine to be the visionary, and not the implementer.

You cannot honestly believe that Martha Stewart creates and makes every single item in her books and magazines. She is brilliant enough to hire talented people who co-create with her. Think about the editors of magazines. They will have a vision of what they would like the cover to look like. They will not be photographing the cover pictures themselves; they will hire the photographers, express their creative vision, and co-create with each other. It's not about taking it all on. It is about collaborative co-creating.

Some of the most fabulous work that has ever come out of my shop has been co-creative work. We would brainstorm about colors and textures, form and needs, and then one of us

> Determine your priorities. Create your work around those priorities.

would start creating and... wow! A designer, and it could be me, took the visions, and flew with it, given the support and environment in which to create. Each designer worked from their own brilliance, creating something more beautiful than any of us could have conceived on our own.

Be willing to relinquish tasks to the group's creativity. You do Not have to do it all yourself!

BE HONEST AND CLEAR IN YOUR PRIORITIES

Determine your priorities. Create your work around those priorities.

You must be completely honest with yourself, or it won't work. There is absolutely nothing wrong with napping in the afternoon, or anything else you like to do with your time. If you own

> *Acknowledge your preferences and patterns. Make them work for you.*

your own business, and you learn the priceless practice of delegation, and you organize your time to fit your needs, you can create every day to look like what you like. But only you can to that, and truly you must, otherwise you are living someone else's life, according to their needs and desires, and not your own.

You will notice a pattern in your own life in that how you do things in one part of your life will probably carry over into the other parts of your life.

Acknowledge your preferences and patterns. Make them work for you.

I have found it unfulfilling and counterproductive to work against my own grain. Find your grain, know it, and work with it. Swimming upstream all the time is so exhausting. If you were meant to be salmon, you'd have scales.

Organizing is something I hire other people to do for me. Then I have them show me what they did, and why. I usually modify the system somewhat, and then I commit to keeping the system going by using it faithfully, knowing that the reward is afternoon sunbathed naptime and relaxing evenings with Masterpiece Theatre, feeding my fantasy that Jeremy Irons will enter stage left directly into my living room.

PRIESTESS PEARL OF WISDOM

Organization is one of the tasks of running a business that absolutely must be done or you will pay for it in many ways, over many days. Unpaid tax bills, invoices due, lost receipts, misplaced orders, tossed statements of discussions with employees, advertising copy having to be created anew each time you want to run an ad ~ it goes on and on and on. Even the locating of a certain tool or container for a certain job can drive a perfectly sane person into a tizzy of frustration.

Running your business to be both lucrative and enjoyable requires practical, workable systems of organization that are as functional as they are enjoyable to use...so you'll use them!

Satisfying the organizational needs of your business requires you to understand all the different needs of your business as well as being able to be scrupulously honest with yourself as to your own organizational style. You must be willing to admit to what you are, and are not, capable of taking on. You must also admit to yourself the parts of the business you enjoy doing, and do well, while choosing to delegate to others the parts that need to be delegated.

As Priestess Entrepreneur your primary job is to assess the realistic needs of your business, find the appropriate people and systems to organize it and maintain its most efficient functioning.

The more you are able to tell yourself the truth about your personal needs and the needs of your business, the more likely you are to be able to satisfy those needs, making for a happier, healthier, and more balanced life for you and a happier, higher functioning business.

CHAPTER 5

Putting yourself out there…
your most important commodity ~

YOU!

Five

 etworking. Even the mention of the word can send waves of nausea through the most stalwart of business owners. Networking. Networking means connecting, schmoozing, selling yourself. Handshakes. Smiles. Card exchanges. Being able to tell who you are and have EVERYONE want to do business with you in thirty seconds or less.

People will be looking at you. People will be judging you. How does the hair look? Am I wearing the right outfit for this gathering? Am I too overdressed? Too underdressed? How does my breath smell? I knew I should have had a manicure before I came to this meeting.

The potential anxieties are endless and ~ EVERYONE HAS THEM!

The only thing you ever need to know about networking is this: as nervous and reluctant as you are to put yourself out there ~ so is everyone else. Know this, understand it, and you have the key to successful networking.

It is the preciousness of our vulnerability as humans that makes for the most successful of networking connecting experiences. The person who impresses you the most, and the one you will remember, is the most REAL and accessible person.

So save the freak-out, all they really want is YOU.

I went to a networking luncheon at my local Chamber of Commerce a few weeks ago. The presenter was a gorgeous Ken-doll of a man. He wore a beautiful suit and sleek Italian loafers complete with tassels. His hair was divine and that face…exquisite. But within moments of opening his mouth

The only thing you ever need to know about networking is this: as nervous and reluctant as you are to put yourself out there ~ so is everyone else. Know this, understand it, and you have the key to successful networking.

he lost his audience. He was aloof, unavailable. He was relating from his head, not his heart, and people just didn't care about him.

For 50 minutes there wasn't a sound in the room and at the end of his presentation not one person raised their hand to ask a question. He never made heart contact as a presenter so he left no impression on the group. He billed himself as a "success" coach. For my taste, he lacked the most important quality of creating success: relationship... the ability to connect from his heart to the audience.

When you are able to connect with another human being from the heart you will be remembered. What is real is remembered. What is false falls by the wayside. The more available you make yourself in your communication the more connection you will have with a person, the more chance you will have of making a customer of them.

At a local women's leadership meeting the other morning I was particularly struck by the candor of the introducer. She admitted that she got up too late to "get it all together" for this 8 a.m. meeting and she had to admit that she was wearing two different socks. Her upfront honesty and self-disclosure of her humanness put the entire group of 100 women completely at ease. Her vulnerability and her ability to laugh at herself in front of so many women created this yummy feeling of connection because every woman in that room could identify with the urge towards, and ultimately never attainable, image of perfection.

Each person in the room not only felt relieved that the leader was wearing mismatched socks but they were also warmed by her admission of such. The sharing of her vulnerability created an instant feeling of connection with many women in the room. She became someone with whom I felt I could do business. She made herself open for business.

The goal of networking is to be open for business.

MAKING YOUR BUSINESS "OPEN FOR BUSINESS"

What makes you buy from one particular vendor and not from another? Why do you use someone for a service and won't try someone else? It's because you have created, or desire to create, a relationship with the other person. In order to create relationship there needs to be open and available lines of communication.

> The goal of networking is to be open for business.

If I am trying to sell you a product or service you have to feel confident in my ability to provide not only in a general sense but to you specifically. This implies that you have to have some sort of positive perceived relationship with me.

My goal in networking is to present myself in such a way that I express to you that I am available to have a business relationship with you. I do this by making myself available through my heart connection to you. The only way I can make a heart connection is by presenting the real "me."

Networking is all about creating relationship. As you successfully create relationship with a potential customer, you move from potential to real. The more comfortable you are with yourself the easier it is to create meaningful, and successful, relationships with others. As with everything in business, it all comes back to your relationship with yourself, your work being a logical extension of who you are and how you present yourself to the world.

The more you resonate with your true inner self the easier it is to pres-

ent yourself in the world, the more successful you will be in your relationships and the more successful you will be in your business.

Healthy relationship with Self manifests as the ability to create healthy relationships with others. Bringing this thought to its logical conclusion: as successful business is all about successful relationship, and the business is all about you, then healthy relationship with yourself ultimately manifests as healthy and successful business relationships.

> *The only way to make a heart connection with someone is to present the real you.*

Ah! Often easier said than done, but a worthy goal to pursue. The outcome of successful business as manifestation of right relationship with, and truthful presentation of, yourself is the gift and desired end in itself.

GOOD LISTENING MAKES FOR GOOD RELATIONSHIP

Just as you need to perfect the practice of listening to yourself (so you know how to meet your own needs), the most important thing you can do when you meet a potential client is to be a good listener, so as to be able to decide if you can meet their needs. A good listener listens with the heart as well as the ears. Look into their eyes. Think about connecting to their emotional body, not just their words. Hear what lies below the surface chatter.

Share only briefly about yourself and then listen, listen, listen.

The most effective way to engage with a potential customer is to give them your full attention, exchange cards, and then contact them within a few days of connecting with them. I usually send a small handwritten note, enclosing my business card, acknowledging meeting them, reminding them of my services and my availability to them personally.

I find that the personal hand-written note is worth a thousand pre-printed flyers and reminder postcards.

The desire for real human connection is one that can be satisfied by the

small businessperson, giving us the edge over a corporate entity.

The yearning for the personal connection has never been greater than it is today. Reach out to someone as you would enjoy being contacted. I never call ~ I always drop a written line ~ the impact is great, much appreciated, and non-intrusive.

When you handwrite a note there is a bit of you that you pass on to the receiver. A handwritten note is a gift of yourself that you share with another. Each time you reach out to another person in sincerity you will be remembered. The personalized connection is so *The more you resonate with your true inner self the easier it is to present yourself in the world, the more successful you will be in your relationships and the more successful you will be in your business.* important to create a connection through the heart.

It is through our hearts that we connect, that we draw to us all that we need. Opening the doors and being "open for business" is not always the same thing. If your heart is not open, neither is your business.

LOLA AND DORA

Lola and her husband own a very high-end restaurant downtown. The décor and the ambiance are lovely ~ very romantic. A jazz musician plays their baby grand piano. The lighting is impeccable. The food is exquisite. But I don't like going there because of Lola. She always looks like she just crept out of her hospital bed after a bad accident. She looks disheveled, exhausted, and really sad. I get so sad when I see her that I don't want to eat there. Lola's unspoken message to me, the customer, is:

"I'm exhausted. This restaurant's killing me. Are you sure you want to come in?"

The restaurant is failing. It's been open less than a year.

Dora owns a breakfast/lunch diner type place in a strip mall. She has been there for over 30 years. The food is greasy and impossible to digest. The décor is country Czech, with lots of formica and plastic flowers. Everyone loves to go there ~ it is always packed. It's because of Dora. She is so vibrant and vivacious. She welcomes each customer and makes everyone feel like they are in her kitchen and she is thrilled to have you.

> *Share only briefly about yourself and then listen, listen, listen.*

Each of one of these women is using herself as a commodity for her business ~ Lola to the detriment and Dora for continued success. Dora understands the impact of heart connection; she understands that a happy, heart-connected customer will keep coming back over and over again, erupting gallbladder or not. Customers come back for the Love.

LETTING YOUR PRODUCT SPEAK FOR ITSELF

A highly effective way to promote your business is to let your products and/or services speak for themselves. You do this by giving things away WITH your card attached. The more people can experience what you are offering the more likely they are to try your service.

When I first opened my business, my tiny shop was tucked away in an alley next to a parking structure. My shop was as close to being invisible as it could be and still actually be there requiring rent to be paid. I could not depend on walk-by traffic; it was a destination shop. People had to WANT to get to me or surely they never would. The chances of just being stumbled upon were slim to none.

I propelled myself into the community, letting people know I was there. Petrified as I was to put myself out there, I was more petrified of not being able to pay the rent. I made tiny little dried potpourri sachets, with my business card dangling from a ribbon wrapped around each one.

Wherever I went I gave out potpourri sachets bedecked with my business card. I gave them out at every networking event. I gave them out anywhere else I happened to be when people would ask, as they are want to do, "So, what do you do?" I'd hand them a sachet and invite them to visit me at my shop.

Each week I delivered a bouquet to the Chamber of Commerce. My arrangement, business card tied with ribbon to the vase, with a note thanking them for their referrals, always brought in lots of business and heartfelt appreciation. The Chamber of Commerce is one of the first places people call for information on local businesses. Through the Chamber we received many new accounts, and lots of orders from out-of-town. Most of these out-of-town customers used our services for all the years I owned the shop and were a steady source of income at all major holidays and family and/or business celebrations.

> The desire for real human connection is one that can be satisfied by the small businessperson, giving us the edge over a corporate entity.

When I had flowers too old to give away for display I donated them to our local Safehouse for women and children. I donated flowers to them, or another non-profit organization, on a weekly basis. Flowers that I might have considered too old to sell were greatly appreciated by people whose spirits needed lifting. It was my small way of giving back to the community. Sometimes we sent plants and flowers to the local nursing homes or to the waiting rooms of the hospital. We hardly ever threw anything away, keeping

the energy of the shop flowing through the community. That flow would eventually bring more business my way. Everything that goes around comes around, in one way or another.

JOIN, JOIN, JOIN, AND THEN SHOW UP

Joining networking and support groups is a highly effective way to get your business jumpstarted. These groups provide an arena for you to practice presenting you and your business. Networking groups are safe environments in which to test your networking wings. Learning to speak in front of a group about your business can be personally empowering and is great for promoting your products and services. Check out local Toastmaster groups.

The two networking groups that I joined during my first year in business provided me an arena in which to talk about my business and to make business connections. Some of these business connections have blossomed into friendships of many years. My fellow entrepreneurs became more than just friends; they became confidantes, advisors, and support for me as I grew my business.

It is through our hearts that we connect, that we draw to us all that we need. Opening the doors and being "open for business" is not always the same thing. If your heart is not open, neither is your business.

We traded each other's services and products, creating a true network, or web, of interconnected and complementary businesses.

I also joined my local Chamber of Commerce, where I attended classes, workshops, and social events. I found the Chamber to be an invaluable part of my business growth. The care and support I found in the people

who were affiliated with the Chamber helped to form the foundation upon which my business grew.

Join organizations and groups to which you honestly feel you can make the time and energy commitment.

Selecting a few venues where you can focus your networking is best. If you overextend yourself or over commit yourself you will find yourself getting resentful. Eventually you will stop going and lose the potential to create long-lasting, mutually supportive relationships.

Customers come back for the Love.

In the case of personal one-on-one networking, more is not necessarily better. Try out some groups. The ones that you resonate with, the ones in which you feel most comfortable and most aligned in values, are the best places for you to promote yourself and your business services and products. Showing up to one or two groups that are a real "fit" for you is much more effective than spreading yourself too thin, and then choosing not to attend any groups at all. Moderation and compatibility are the keys to help you to show up.

Join organizations and groups to which you honestly feel you can make the time and energy commitment.

Just start showing up and you might be very surprised at how effective a marketing tool that becomes. You are your greatest marketing tool. You is who they want anyhow, so just use YOU.

PRIESTESS PEARL OF WISDOM

The essence of effective marketing and promoting of your business is the outcome of presenting the real YOU. The more aligned you are with your values and your beliefs, and how those values and beliefs are represented through your business and your work in the world, the more customers will be attracted to support you and your work. People are attracted to that which is real and heartfelt in one another. All that is false falls away as the real you shines through.

Creating supportive networks of business contacts is the sane and healthy way to keep your business an active member of your community. The more people know about you and your business, try your products and services, and the more heart connection they feel with you, the more your business will grow and prosper.

> You are your greatest marketing tool. You is who they want anyhow, so just use YOU.

Get out there in your community by joining a few networking/support groups and by joining and supporting your local Chamber of Commerce. Be visible and available for listening and connecting with potential customers. Get the guidance and support you require to put yourself out in your community. Learn to put your best self forward, your true and real self. What everyone really wants is YOU.

CHAPTER
6

I Cannot Believe this is
Happening to Me ~

MANAGING DISAPPOINTMENT

Six

Disappointment provides the ideal opportunity to see how flexible and secure you are in your role as a Priestess Entrepreneur. Disappointment gives you the opportunity to shed any remnants of being a victim, to truly stand on your own, fully responsible for how you perceive your experiences.

Remember: it is by claiming full responsibility that you are consciously empowered in your business. If you slide into any thoughts of blame or projection you lose your stance of being fully empowered.

What is the nature of disappointment? Disappointment is not real; you create it with your perception. Things happen, you create them, consciously or unconsciously, you perceive them through your unique filter, and then judge them as good or bad, depending on that filtered perception.

Everything is filtered through your perception.

Nothing is real unto itself outside the realm of your perception of it. Not that events do not exist outside of your perception for of course they do, but they have no meaning in your life unless they come into your experience. If you are thinking about it, it is in your experience and you are processing it. If it is in your perception it is for you. What you choose to do with that information or perception is entirely up to you. I call this *perception management*.

All disappointment stems from expectation, a distorted form of perception management.

Every expectation is a potential set-up for disappointment. Living in

expectation is living in the future. If you are living consciously in the present you will not have expectation and then you will not be set up for disappointment. You have absolutely no control over people, places, and things. You only have control over yourself and how you experience your world.

Remember: it is by claiming full responsibility that you are consciously empowered in your business. If you slide into any thoughts of blame or projection you lose your stance of being fully empowered.

When you set yourself up to have certain expected outcomes and remain emotionally attached to your idea of how things are going to be, not only do you set yourself up for disappointment, you close the doors to the possibility of other opportunities you have yet to imagine.

Considering the exquisite complexity of the universe, the chances of anticipating, expecting, and being thrilled with an outcome is small ~ unless you are open to expect the unexpected. In the everyday ebb and flow of running a business you will be faced with disappointment on a daily basis. You will perceive disappointments as such, and not as opportunities, as long as you are attached to the outcome.

Every time that I have surrendered to an outcome that is other than what I thought I wanted, I was happily surprised that things turned out better than I thought they would, regardless of how they might have initially appeared.

Disappointments aren't always about people and circumstances outside of us. Sometimes the greatest disappointment we experience is from our own behavior.

Often we have higher, and more unrealistic, expectations of ourselves

than we do of anyone else. Ask any woman running her own business and she will unfailingly tell you that she could work an ungodly number of hours in harrowing conditions at breakneck speed, and she would not dream of expecting her employees to do the same (though secretly she would admire and respect anyone who would stick with her through the long haul).

Disappointment is the opportunity to turn circumstances around, to create an outcome for which you can be joyful. Disappointment gives you the opportunity to learn, to see how you can turn lemons into lemonade, or better yet...sorbet!

Business-related disappointments will fit into one of the following categories:

1. Cash flow
2. Interfacing with the system
3. Behavior and choices made by other people ~ staff and customers
4. Events happening beyond your control

CASH FLOW

This is the kind of disappointment that shows up as less money coming in or more money going out than expected, or needed ~ the general slowing of business and flow of available resources.

This might sound like: "Oh, I bought so many tulips this week and no one bought any. Now I have so many left over and I have to get rid of them. Since I paid $200 for the tulips and with my usual mark-up of 2.5 for product sold by the bunch, I should be bringing in $500. But I have not sold a one! What can I do?"

I could feel disappointed that I didn't have more customers that week or I could take this as an opportunity to look at my marketing and advertising strategies. If I was going to have a surplus of flowers that I wanted to move, don't I have to let people know about it? I could have run a promotional ad in the local newspaper or enclosed a little promotional flyer in all purchases

that left the shop. I did no promotional work and so was left with too many tulips.

I took the tulips, put each bunch in a mason jar that I purchased for next to nothing at a garage sale, put the store tag on it and gave them away to local businesses. I included a note saying how much I would like to be their personal florist and that we offer specials every week. I used my surplus of tulips as a gesture of friendliness and an opportunity to get my name into offices where they may not have previously known the shop. I turned my disappointment into action to get the energy flowing.

All disappointment stems from expectation, a distorted form of perception management.

Probably the most disappointing time of my entire business experience was the very first Valentine's Day that I owned the shop. I had opened the design school/shop in September of 1991. By that time I had, off and on, about 14 years of flower shop experience. Coming into February I was anticipating a brisk business of Valentine's Day flower sales, as I always experienced February 14th to be THE busiest flower holiday of the year.

I advertised in the small way that I thought my budget would allow, running a few barely noticeable ads in the local newspaper. I reminded my Leads group (my networking group) of the big day. I loaded up the cooler with flowers, did as much prep work as I could and waited for the business to roll in. I had one employee at the time, a really nice woman but one who had had no prior flower shop experience, hence she had no preconceived notion of what the day "should" look like.

We had a trickle of business. I could feel the panic rising in my gut. By around 4:00 the weather started rolling in. By 5:30 a huge downpour of freezing rain was beating down in the alley outside my shop. Being located in the corner downstairs of a parking garage, our busiest time was when

people left work to go to their cars at the end of the day, at about 5:30. By that time the rain was coming down in bucket loads. People were running to their cars, thinking only about getting home ~ not about flowers.

A few dedicated and caring customers braved the weather and came by (Bless each and every one of them). I was absolutely sick with sadness and an overpowering feeling of failure. I sent my employee home when her boyfriend came by to pick her up for a romantic dinner at 6 o'clock. I let her go as there was nothing left to do but cry. And cry I did.

I locked up, leashed up Beatrice, my Airedale, and we headed home. We had to walk because my car wasn't working, or maybe I was in between cars, for whatever reason I had no car. That half hour walk in the rain on that saddest of Valentine's night with no boyfriend, no car, and a flower shop that sold hardly any flowers for the biggest holiday of the flower year, was the most miserable night of my business career.

When we finally got home my roommate was having dinner with his date. I went to my room and wept myself to sleep.

I didn't want to go back to the shop the next day. In fact I never wanted to go to the shop again. But I did. Beatrice dragged me down there the next day, as

> *When you set yourself up to have certain expected outcomes and remain emotionally attached to your idea of how things are going to be, not only do you set yourself up for disappointment, you close the doors to the possibility of other opportunities you have yet to imagine.*

it was our routine. The rains had blown the air clean and it was a lovely, crisp day, full of promise. I opened the shop and my heart melted because I really

loved that little shop so much and the flowers were so pretty and I felt so good in there. I gave myself a very serious scolding for being so hard on myself for my first holiday in my very first shop. When I went over the numbers I realized that I hadn't made one penny, but I hadn't lost any either. I covered all my expenses with what I brought in, so I certainly could be pleased with that, and I chose to be.

I realized that I had set myself up for such a disappointment because I was living in the fantasy of how it was at other shops ~ shops that had been up and running for years. How unrealistic of me to set myself up in that way. I did the best that I could do and for being open for only 6 months, I did just fine.

Sometimes the greatest disappointment we experience is from our own behavior.

When Mother's Day came around that same first year, Mother's Day being the next largest flower holiday, I did not set myself up for disappointment in the same way. I bought conservatively and I set a realistic projection for what I expected to bring in for that holiday. I actually did better than I had anticipated and I didn't berate myself for not being as busy as other shops. I knew the business would grow. Staying in reality and not propelling myself into fantasy projection really helped me to have a wonderful, appropriately lucrative, holiday.

By Valentine's Day in 2001, I had 15 people working for me, a store twice the size of the original shop, and over 20 times the amount of business of that first Valentine's Day ten years prior. By 2001 I was weeping not from sadness but from delirious exhaustion and bursting with pride at how successful a business I had grown. I hugged my little stuffed animal version of Beatrice, (she had passed on to doggie heaven in 1999) and knew I had come a long, long way.

INTERFACING WITH THE SYSTEM

The most traumatic time in the life of my business was when I chose to move to a larger location from my tiny store hidden behind the downtown mall at the opening to the parking structure.

I was fortunate to be selected as one of the businesses to occupy a strip mall that was being upgraded as "the" place to shop in town. It was a very desirable location, being among upscale shops, some old time town favorites that had been there for over twenty years, kitty corner to the hospital, and offering lots of free parking. The down side of the move was that my space was one of six spaces being created out of an old grocery store. Each tenant was required to do all the building of the space to create it for retail use. For me, this was an overwhelming task of incomprehensible magnitude, requiring not only skills I did not have, but funds I did not have either. Not to mention I had to oversee the build-out of the new store while running the old store at the same time.

The build-out was an endless unfolding of disappointments, piled so high and so deep I wasn't sure I would ever find my way through to the other side. The insanity was highlighted by the drama involving the phone service.

It seems that when the strip mall was refitted for more businesses, the phone company had not created enough lines and access for all the businesses. This was a time when cell phones were just introduced on the market and were for emergency use only, being prohibitively expensive to use often and frequently. It was unthinkable to consider using a cell phone to run one's business at that time.

Plan ahead, take appropriate action and stay on a problem until ultimate completion and satisfaction.

When I was still at the little store, before the planned move, I had arranged to have my phone service transferred to the new location. My business was 80 to 90% phone business so I was very dependent on functioning telephone service.

When I finally was ready to start doing business at the new shop there was no phone service hooked up. The guy who had the bicycle shop next door had no service and was told that he wasn't going to get any either. I panicked.

I began my relentless and insistent calls to the phone company, and I mean relentless. I tried every trick I could think of to have them acknowledge my initial request for phone service which I had made over four months prior, their o.k. to hook up service and their responsibility to make this happen for me. It took me about three days of dogged determination to finally connect with one woman, eternal thanks to her, who dug up the files in the complex web of the phone company and admitted that she could see that I had requested, and was granted, phone service at my new location. It was only because I had requested the service so many months before that I was one of the few tenants that received the phone service shortly after I opened. The bicycle guy closed his shop, before he ever received service.

Participating in this drama taught me the value of planning ahead, taking appropriate action and staying on a problem until ultimate completion and satisfaction.

Any time you have to interface with a large corporation like a bank, a credit card company, the phone company, Public Service, or any system that you need to make your business run, make sure to follow these steps:

Depersonalize your response and get to action ~ with clear thinking, determination, and politeness.

104

- Keep a written record of all contact you make with the company by recording the date and time you spoke with their representative, what that person's name is, and the nature and content of the call. Put this info in a file you keep for just this business.

- Every time you call ask to speak to the same representative, if at all possible. Never underestimate the value of creating and maintaining a personal connection with the anonymous person on the other end of the line. Make that person no longer anonymous.

- Ask as many questions as is necessary for you to feel that you COMPLETELY understand EXACTLY what the processes, charges, and services that you can expect from the business you are dealing with. Ask as if you were new to this planet. The more direct, focused, and simple the questions, the more complete and satisfied you will be in understanding all dealings with this business. Do not leave yourself open for any surprises.

- Do not accept bills and charges at face value. If you do not understand why you are being charged for something, call the company and ask. Sometimes charges are put on your bill that you did not request, do not want, and can be removed. Scrutinize every bill and charges sent to you. Being informed is the best guard against being taken advantage of.

- Send thank you notes for services well done and appreciated. I sent flowers to the woman at the phone company who made my service come through to me and a letter to her boss commending her superlative customer service. I believe in putting as much good into the work world as possible. Notes and acknowledgments of a job well done is a fine and good practice to embrace. As my mother always said: "You catch more bees with honey than with vinegar". I know that if I ever had a problem with my phone service I could call that woman and she would go to bat for me because she felt appreciated and acknowledged by me.

Remember that a company is not out to get you personally; it's never personal, though it might feel that way.

Depersonalize your response and get to action ~ with clear thinking, determination, and politeness.

BEHAVIOR AND CHOICES MADE BY OTHER PEOPLE

I guarantee you that this is the area that will drive you to indulge in your favorite addictive behaviors ~ chocolates, alcohol, sedatives, uppers, movies, whatever does it for you to take you outside the reality of having to deal with other people's choices and behaviors. As much as you think you know a person, you don't.

You will never completely understand a person's motives and you will never be privy to their secrets and their life choices.

Though some people are easier to read and understand than others, I assure you that as soon as you think you understand someone they will surprise you. It is the beauty, wonder, and frustration of our curious species. It is also the venue for you to practice your business skills of "no expectations".

The other crucial thing to understand in your dealings with other people is: take NOTHING, absolutely NOTHING personally.

You will never completely understand people's motives and you will never be privy to their secrets and their life choices.

You might have to go to into intense therapy to learn this but it is well worth it. Most people make decisions based completely on what is happening for them in their lives and in their minds. It hardly ever, if at all, has anything to do with you.

As a boss and business owner we often can become so focused and

centered on our business, because for us it is our entire life, that we forget that the people who work for us and the people who use our services have their own planetary system that they revolve in, and it is their own ~ not ours.

The most important things to remember when dealing with other people vis-à-vis your business are:

- Your business will never be as important to someone else as it is to you.
- People make decisions for their lives that have to do with their own needs and desires, not yours.
- Take Nothing, absolutely NOTHING personally!

I learned these tenets the hard and miserable way. Each and every one of these truths I came to after much hair-ripping, self-questioning, therapy work, and final surrender. The sooner you grasp and incorporate these truths the happier and more content you will be AND the better decisions you will make for you and for your business.

DECISIONS MADE BY YOUR STAFF

Disappointments related to the choices made by employees can be particularly difficult to manage. For me, the problems I experienced with my employees occurred because I thought of my employees as my extended family members.

When you see your employees as family you also place unrealistic expectations on them that is unfair to you and to them. Good luck ~ this is a hard one to do, as our tendency is to become very close and intimate with our coworkers and the lines are easy to cross. The trick of balance is to love and respect your employees and also to remember that they are with you for a period of time and should it serve them to move on to something else ~ they will. Their leaving is not a reflection on you or their feelings for you but more likely just an appropriate move for them.

When my main designer left to go live in the mountains with her boyfriend two weeks before Valentine's Day I took that pretty hard. Though she had given me many months notice, I could not accept that she would not stay and help through Valentine's Day. The truth is that I was personally upset by this. I felt abandoned. She had worked for me diligently and wonderfully exactly when she said she would. She gave me plenty of notice to find someone else to replace her for that holiday. I took it personally that she did not see that she "should" stay and work through the holiday. That was my problem, not hers. I wanted to make it her problem, so I wouldn't have to deal with replacing her and the implications that replacing her would mean to the store, professionally and to me, personally.

It happened that she left, I replaced her, and the holiday went just fine. We are still very close and dear friends because I got out of fantasy and stepped into reality.

 Your business will never be as important to someone else as it is to you.

 People make decisions for their lives that have to do with their own needs and desires, not yours.

 Take Nothing, absolutely NOTHING personally!

EVENTS HAPPENING BEYOND OUR CONTROL

At 8:30 a.m. on a frosty Colorado morn, Lisette, creator and owner of a high-end skin care clinic, called me in hysterics to tell me that the previous night a drunk driver had plowed through her parking lot, took the fence down, and wedged himself and his car into the front lobby of her building. The entire lobby was now destroyed, as were the two bathrooms in that part of the building, the beautiful displays, and built-ins that she had

so lovingly created. All the electricity and gas and water were off. Business would be at a standstill for an undetermined length of time. She had just completed an entire remodeling of the building, had secured all the financing for it, and had launched a large marketing push to amp up her business. On a more sentimental note, we had just completed her holiday decorating, which had been tastefully tied to her December promotional for her products and her services.

What a devastating shock to a business owner! The ramifications of this accident created a living nightmare for her to sort out and deal with, requiring complete and total surrender to an event outside her control. While she was in her bed snoozing, her business was the scene of a devastating accident.

Lisette had a very challenging time handling this event. She had struggled with her over-attachment to her business. Over the twenty years she was growing the clinic, she had fears that she would lose the business, triggering huge issues of shame and failure for her. She chose to get professional therapy for herself, to guide her through the trauma this accident created for herself and for her business. She successfully rose above the potential nightmare of the accident by focusing on her own emotional needs first and then dealing with the needs of the business.

Almost five months later the clinic was fully operational. The business itself received a facelift and Lisette grasped the opportunity of the sequence of events to create healthier boundaries between herself and her business. She came to realize that she is NOT her business. She is herself, first and foremost, the business a natural extension of her interests and passions. Were the business to no longer exist ~ she would continue to!! Her greatest fears of losing her business, and consequently herself, had been nearly realized. Having successfully lived through her greatest fear, she has developed a healthy detachment towards her business.

PRIESTESS PEARL OF WISDOM

Handling disappointment effectively is what I call *perception management*. An event happens and it affects your business. How you choose to deal with the event creates either disappointment or opportunity for growth. The Priestess Entrepreneur grasps the opportunity latent in perceived disappointment and uses the experience to learn more about herself and her expectations. She transforms thwarted expectations into gems of self-knowledge and increased success for her business. She creates forward movement in her business by embracing self-knowledge and turning it into change for the better, for herself and for her business.

CHAPTER 7

WHO DIED AND MADE ME MOTHER?
The Joy and Nightmare of Having Employees

Seven

You certainly don't have to birth babies yourself to have certain people think you're their Mother. If you manage a staff and you're a woman, some of those employees, maybe all of them, will think you're the Mother. There is no way around it. Even if you do not see yourself as the Mother, chances are you will be seen as such. You make the decision to hire and fire. You sign the paychecks. You give or withhold praise. You sit in the power position. The Priestess Entrepreneur stands strong in her power, working to maximize each person's experience, especially her own, within the dynamics of these potent relationships.

Acknowledging and respecting the inherent responsibility as leader in her relationship with her employees, the Priestess Entrepreneur uses her position to empower herself, her staff, and her business.

Empowerment is born of awareness; it flourishes in your commitment to be yourself, consciously and responsibly.

As an owner you are ultimately responsible for the livelihood and viability of your business. Like a mother who knows the different personalities and unique needs of her children, the Priestess Entrepreneur knows the personalities and needs of her employees. If your employees are still working with issues around their mothers, and if they haven't worked through their issues with their father, you will also somewhat be perceived as the Father as well, being as you are the authority figure.

In my flower shop I often felt like I was running a finishing school for

young women. My staff was composed predominantly of women ranging from ages 18 through 30. Occasionally, though not often, I would employ someone closer to my age, or older. I came to love and adore my staff as if they were my own children.

I experienced wonderful and challenging opportunities for growth through my relationships with my staff. My staff burst my heart open with Love, pushing me to grow and expand myself as a business owner and as a woman. Challenges arose when I became embroiled in their dramas. I was over-involved in their lives because I was the classic codependent boss.

CODEPENDENT BOSS

Codependence is the behavior pattern of being over-involved in another person's emotional process to the exclusion of one's own needs.

Placing other people's perceived needs above one's own and those of the business is the curse of the codependent boss.

In my experience most women I know who run small businesses are wildly codependent. It's a woman thing. Most women have been accultur-ated to give to everyone else first, leaving the crumbs for themselves. Those of us who have patterns of codependency have to unlearn these behaviors, replacing them with balanced, more self-caring ones.

Empowerment is born of awareness; it flourishes in your commitment to be yourself, consciously and responsibly.

I am a great be-liever that unhealthy behavior patterns yearn to be healed, that our souls crave balance and peace for each one of us. As an unhealthy behavior is called up to be healed, situations will arise, created either consciously or uncon-sciously, which expose that behavior to the opportunity for transformation. The workplace is a potent arena for unhealthy behaviors and dynamics to

play out, as it also is a perfect arena to facilitate the transformation of these behaviors from unconscious, reactive patterns into healthier, self-supporting behaviors.

As codependency is a pattern yearning to be healed, our soul calls forth the opportunities to attempt emotional healing. By identifying and acknowledging these patterns the Priestess Entrepreneur exposes this emotional wound to the healing light of consciousness. An unhealed emotional wound, when exposed to consciousness, opens itself up for healing, i.e., transformation, into more integrated, healthy behaviors.

Placing other people's perceived needs above one's own and those of the business is the curse of the codependent boss.

As you learn to practice healthier, more balanced behavior, you empower yourself and your staff by allowing them to feel the consequences of their choices.

When the empowered boss stops wiping her employees' noses, the employees will wipe their own or move on to another place of work. The more you overdo for an employee the less empowered she will be. When you overdo for an employee you are enabling her behavior born of her wounds. When you transform your own codependency into empowerment you provide a role model for self-care and responsibility.

If codependency is left unattended the codependent boss runs the enormous risk of creating self-sabotaging experiences, ones that support her misguided belief that she can never give enough or do enough, that she herself is not enough.

I was committed and determined to free myself from the self-sabotaging behavior of codependency. Every day I had the opportunity to practice by creating appropriate boundaries, learning to be the boss not the buddy, the healthy role model not the savior.

You can deny that there is any codependency in your business and that this isn't how it is for you, but chances are you would be lying to yourself. Some dynamic of authority figure/child will be played out in some ways if you are paying someone to perform services for you. As most of us were raised with moms who were self-denying over-givers, and since the workplace tends to mimic the home environment,

As you learn to practice healthier, more balanced behavior, you empower yourself and your staff by allowing them to feel the consequences of their choices.

chances are you will act out similar behaviors in your workplace.

Codependency is a manifestation of the misuse of one's power. Codependency is the result of giving one's power away to another person. As a boss the issue of power is always present. As power is a provocative issue for a woman, it is doubly so when she is the boss. The Priestess Entrepreneur acknowledges that power is an issue for women. She makes the commitment to understand power, how she uses it, how she abuses it, and how she may give hers to someone else.

POWER

The Priestess Entrepreneur asks herself:

- ◉ Do I understand the nature of my power?
- ◉ How effective is my use of power?
- ◉ Am I willing to step fully into my power?

How a woman utilizes her power and her feelings of her own self-empowerment directly informs to the amount and quality of success she will experience in her business. To embrace this responsibility and opportunity,

to make a positive impact on my world, I had to acknowledge and embrace my own sense of power ~ I had to empower myself.

Power is perhaps the most abused energy source in our interpersonal relationships. To be in one's own power, i.e. to be empowered, means to be clear and centered in the truth of oneself. Power, as understood in this way, is not a function and tool of the ego, but of the highest Self. True power lies in one's ability to be true to oneself while allowing other people to be true unto themselves.

As the owner you have the opportunity to empower yourself and your staff. If people are functioning from a centered place of self-empowerment, they will not only be better employees, they will be better citizens of the planet. As leader of your small group you have the opportunity to teach and be a role model for empowerment.

First and foremost, you must do your own healing work on yourself to examine and heal your issues around power and authority, your issues around your mother and father. So much of how you run your business will be an unconscious reflection of how your family functioned and what role you played in the family system.

If codependency is left unattended the codependent boss runs the enormous risk of creating self-sabotaging experiences, ones that support her misguided belief that she can never give enough or do enough, that she herself is not enough.

As you become able to identify your own behaviors and patterns as either those of your parents, or those created in response to your parents and/or your siblings, you will be able to run a smoother and more harmonious business.

The arena that the dynamics get most significantly played out will be in the area of communication and personal feelings of self-esteem.

FAMILY COMMUNICATION

How you learned to communicate in your family of origin, as well as how your employees communicated in their family of origins, will get played out in your business. Until they become manifest you will perceive these patterns unconsciously. When you are able to identify the behavior dynamics you are in a position to work with them. When you are able to work with a relationship dynamic and not have it work on you in your unconscious, you have stepped into your power. You move from being a victim of others to a proactive creator of your experience, the essence of true self-empowerment.

> To be in one's own power, i.e. to be empowered, means to be clear and centered in the truth of oneself.

This works the same for you, as owner, as it works for your employees. If you have not worked on healing your emotional wounds, you will run your business from those wounds, and not from your emotional health. If you have an employee who has not worked out an emotional wound with her parents, she will bring that wound with her to the workplace where it will inevitably be played out. As our psychological pain yearns to be healed, it will reveal itself in all kinds of ways until it is addressed.

One can never effectively hide a wound. An unhealed wound gets bigger the more you try to hide it away. It's like sitting on a giant ball in a swimming pool. The more you try to push that ball under the water the more powerfully it shoots back at you, trying to burst free of the pressure. The wound is like that ball, refusing to disappear under the water. The more pressure you put on it to have it disappear the more

powerfully it will try to hit you in the face.

Because the work environment often recreates one's early family dynamics, one has the opportunity to heal and integrate unhealthy learned behaviors that may have served as children, but no longer serve now that we are adults. The group setting of a business and the relationships that develop there can help to transform codependency into awareness, evolving into commitment to create more balanced and healthy behaviors. The Priestess Entrepreneur breaks through her own codependent behavior patterns by utilizing the potential of the group to practice healthier behavior choices.

One of the most profound healings I experienced through my business experience was the transformation of my unhealthy codependent behavior into healthy self-caring and self-affirming behavior.

> *True power lies in one's ability to be true to oneself while allowing other people to be true unto themselves.*

The group aided me in seeing my codependent behaviors. I searched out support for myself to transform these patterns. By identifying my codependence and choosing to heal that emotional wound I was able to empower myself to grow into a happier, more satisfied woman and a more effective business owner.

EMPOWER YOUR EMPLOYEES ~
WHAT MAKES YOUR EMPLOYEE TICK?

One of the crucial things to understand as an owner is to know that each employee must be treated fairly, though differently. If you want to get the highest level of performance from an employee, you need to know what motivates her to perform.

Some employees are there for the money, some for the experience, some for the learning, and some for emotional reasons. The more you know

about what makes your employees click and what motivates them, the better a relationship you are able to foster with them and the better an employee they will be for your business. Every employee is a human being, with qualities that could work well to grow your business and qualities that might become deterrents.

As Priestess Entrepreneur it is completely up to you to support and nourish the qualities of an employee that make her a better employee, empowering your employee to be the best she can be at her job.

> If you have not worked on healing your emotional wounds, you will run your business from those wounds, and not from your emotional health.

Doing a job well, and being acknowledged and appreciated for it, can be a profound source of satisfaction and upliftment for a person.

You can be a most effective manager of people by being aware of your employee's limitations and vulnerabilities, providing as much support as is reasonable while simultaneously not setting up the employee for failure. When you understand what motivates each employee, you empower yourself as owner.

Empowerment is knowledge used wisely.

Here are some common motivators for an employee:

- Money
- Praise
- The opportunity to be creative
- The desire to learn
- Convenience (it's close to where they live)
- Prestige

It is very important to understand what motivates each of your employees. They will be the best employees if what you can offer them is what they want and need. Ideally you want to create a mutually rewarding relationship between you and your employees. This not only increases the performance of your business, it also creates a place of work where you like to be every day.

Let's look at some examples from the workplace. These scenarios identify the underlying emotional wounds that trigger the behaviors, and the choices that were made to address the issues.

BELLA

Bella was a fabulous designer who worked for me for a few years. She was my age (40's) and so I erroneously thought that she would be emotionally mature. I could not have been more mistaken. Do not assume a person's level of emotional maturity by their chronological age ~ they are not related.

Bella had very painful unresolved issues with her deceased mother. She had issues with her self-esteem because she felt she had never been "seen" or appreciated by her mother. No matter what she created or how well she was received in her work she could never receive enough praise and kudos from me. Bella was never satisfied with her day unless I stroked her constantly and

If you want to get the highest level of performance from an employee, you need to know what motivates her to perform.

told her what a fabulous job she was doing. As she never had felt approved of by her mother, she was always looking outside herself for acceptance and approval, particularly from me ~ the female authority figure in her life, i.e., the Mother.

She also had a very difficult time with co-workers. She became jealous

of any new workers, especially if she perceived them to be more talented than she, or if she perceived that I preferred them to her. In her mind she always had to be my "favorite", the one that received the most praise.

On three occasions Bella took it in her own hands to "discipline" a fellow worker by barricading them in the walk-in cooler or the bathroom with her. Behind these closed doors she would yell at them and berate them, all in the name of doing what was best for the shop and for me. She was also the creator and perpetuator of gossip and lies among the staff. She deferred to me in an extreme manner, showering me with fawning behavior and overly attentive acts.

As Priestess Entrepreneur it is completely up to you to support and nourish the qualities of an employee that make her a better employee, empowering your employee to be the best she can be at her job.

As with all employees, there were things about her that made her valuable to my shop ~ she was always on time, 100% dependable, trustworthy, and very talented. On the down side, she was inflexible and often created drama where there was none.

You might be wondering if I stepped in to change some of the ways that Bella was relating at the shop, especially to the other employees. If I had been more aware of my way of dealing with conflict, I would have been more proactive, but I was not. At that time I was still functioning from my dysfunctional management style which I call: "Give them enough rope and they'll hang themselves."

I learned this from my family of origin. As a child I was left to figure things out on my own. If I did well I received no feedback from my parents. If I did poorly I was scolded for my ignorance. As a business owner I had to learn to give clear direction, support my staff in their learning process, and

then give positive reinforcement. As I did not learn that in my upbringing I had to teach it to myself. I learned this more effective way of communica-

Empowerment is knowledge used wisely.

tion as I saw that when I treated my staff as I had been treated, the results were unsatisfactory for the business. When I became more involved in directing and managing, confronting inappropriate behavior by the staff to one another, I took back the reigns of control at the shop and stepped more into my power as leader.

When you step into the role of the leader and are in your power, everyone feels better because they know you will handle what needs to be handled so they can just go about doing the work you hired them to do. WHEW! What a relief!

I knew that I needed to let Bella go because she was disrupting the flow of the productivity at the shop by refusing to perform all the tasks needed of her and for creating emotional turmoil in her wake. The other employees had problems with her and it was becoming a bad situation. Because of my codependent tendencies I kept her on entirely past the time when I should have fired her because I thought I needed to protect her feelings. I wanted to be the "good" mommy at the expense of being the good boss. I made choices to protect her over making the choices to do what was in the best interest of the business.

Taking care of someone else's needs over the needs of the business is what happens when the codependent you, not the empowered you, is running your business.

Bella ended up leaving the shop because her husband's job relocated them to another state. I was relieved but I did not get to confront myself on my codependency in that particular instance. Not to worry! There were many opportunities for me to look at my codependency before I licked it altogether.

You can never save anyone else. Sometimes you hire someone who you come to realize is too emotionally sensitive and dramatic for the work environment you are attempting to create. Being in a creative field I came across a few of these type of employees. I found this type particularly difficult as they brought out the caretaker in me. I usually took it upon myself to get

When you step into the role of the leader and are in your power, everyone feels better because they know you will handle what needs to be handled so they can just go about doing the work you hired them to do. WHEW! What a relief!

right in there with them because of my own patterns of wanting to "save" people. The "savior" complex is a particularly difficult one to identify and shed because it seems the kind and right thing to do at the time. Wrong!

You can never save anyone. If someone's emotional needs and problems are bigger than what you can handle, and their behavior compromises a good work environment, the best thing to do is to let that employee go.

PATRICIA

With a woman called Patricia I got pulled in way over my head, seduced by her brilliance, her gift for marketing, her display work and her fertile creativity. I came to realize that her behavior was too erratic for her to be a dependable employee. She ended up causing entirely too much havoc and mayhem.

Patricia was incapable of sticking to a schedule. She was prone to huge dramatic outbursts of inappropriate emotional display. She did not fit in with the "feeling" of the shop. She would periodically say hurtful and disrespectful things to me, to the other staff members, and to the customers.

I truly liked her and felt that I wanted the shop to be a safe place for her, but that was an absurd savior fantasy of mine. She ended up costing me lots of money and bringing a lot of chaos and disorder to my business. With an employee who displays erratic and unpredictable behavior, you never know what is going to be happening from one moment to the next. This type of behavior problem can be very demoralizing for the other members of the staff, not to mention the crazy making it creates for the owner.

Taking care of someone else's needs over the needs of the business is what happens when the codependent you, not the empowered you, is running your business.

In retrospect I would have been better off to hire her on a project - by - project basis than to expect her to perform consistently in the shop. It is a classic example of not trusting my intuition and trying to fit the needs of the business around the needs of the employee, instead of the other way around.

MISSY

Missy lived with her boyfriend at the time that she worked for me. He had a very lucrative job and though she enjoyed working at the shop, she didn't really need the money. What was her motivation? She was very social, she loved the other girls, and she really enjoyed playing with the flowers. She was a delightful employee, always cheerful and upbeat. The only problem was that she lived about 25 minutes away in the mountains and she liked to leave for two or so hours during the day so she could hang out with her dog. Now no one loves dogs more than me (we had my beloved Airedale, Beatrice, at the shop all the years of her life) but Missy leaving for 2 hours during the middle of the day just did not work for the business. It created a staffing problem and the other staff members were angry that she was

getting this special privilege. I tried to work out a more reasonable schedule with her, but it was unworkable, so I had to let her go.

Missy behaved as if she took the job a little too lightly. I always felt that she did not respect me and disagreed with my management style. It was subtle, but I felt it, and I learned to trust that feeling more and more over the years.

You can never save anyone. If someone's emotional needs and problems are bigger than what you can handle, and their behavior compromises a good work environment, the best thing to do is to let that employee go.

Surprisingly enough, Missy came back to the shop about 6 months later, ways all mended, schedules all fixed, dog issue resolved. After I fired her she went to work for some other florists in town and realized what a fun and good place I had; she wanted back in. I re-hired her, and she became one of my best employees. What I learned from this experience with Missy was that when I made a decision that was right for the business, it would all turn out for the best.

THE ADDICT EMPLOYEE

Gloria worked for my caterer friend Velda. Gloria was in a halfway house for writing bad checks and some other minor offenses. She also was a practicing bulimic. What a set-up for working in a catering business! Velda had a heart as big as Mother Teresa, and thought she was doing Gloria a favor by hiring her. Gloria needed a job so badly and Velda loved to "help".

She hired Gloria to work as her office manager. One of the jobs of the office manager was to manage the checkbook and write checks for bills to the business. One of the things that Gloria was not allowed to do was to

write checks. In that way she was like an alcoholic who, when in treatment, is not to be drinking. Since Gloria's addiction/compulsion was related to fraud, she was not to be left with the responsibility of managing a check-book. Also being an active bulimic with a raging eating disorder, working around food was like a pill addict working at the pharmacy.

Looking at this situation objectively anyone would ask why Velda, a caterer, would hire such a person. Truthfully, most of us have, at one time or another hired, and kept on, the entirely wrong person for the job.

When you are hiring and staffing from an emotional wound in yourself, you will undoubtedly hire the wrong person.

Velda hired Gloria from an emotional place inside of herself, her own wound. She felt bad for Gloria and she identified with Gloria. Velda is dyslexic and had a lot of issues around her dyslexia. She always felt stupid and not appreciated for her true worth. When she witnessed someone else acting out that same behavior in their life, she was unconsciously attracted to them and wanted to make it better for them, as she wanted people to do that for her.

What unfolded was a series of unfortunate events. The most humor-ous, if it hadn't been so sad, was when Velda left Gloria in charge of the kitchen for 2 weeks while Velda was traveling abroad. Upon her return she realized that Gloria had eaten (and of course vomited back up) 22 pounds of the world's most expensive chocolate that Velda had had in the kitchen for her business's extravagant desserts.

Until Velda healed that place inside herself, she would continue to hire the wrong people and for the entirely wrong reasons. She was hiring from her unresolved emotional need for acceptance and approval, not from what were the practical needs of the business.

IT'S MOSTLY CHEMISTRY

Most of the people you hire will be basically "normal" people with whom you either work well with or don't. Ultimately if you are in the healthy power

of your ownership role, you will only have people working around you whom you enjoy. You should never set up a situation for yourself wherein you have people working for you whom you do not like to be around. And they have to like being around you.

EDWINA ~ ONE BAD APPLE

For three years (too many!) I had a member of my staff who just did not like me. She played out her feelings for me in all kinds of subtle, and not so subtle, ways. She made my life a living Hell as I struggled with all the codependency she brought up for me, codependency that I was working out in my business. Remember when I said that if you do not work out your emotional wounds in the appropriate place, you will work them out in your business? With this girl my codependency was a wild horse running from a fire.

Edwina was the first of a few people I "recruited" to work at the shop. I learned that for me this never worked. The best employees I had over the years were ones that were attracted to my shop and approached me to work for me. If I asked someone to work for me it immediately created an "I need you" dynamic, which was used manipulatively against me over time. I found it was always better to hire people who saw the value in working for me.

Edwina came to work for me and thus began one of the most difficult relationships I have ever had with an employee. In retrospect I can see how

When you are hiring and staffing from an emotional wound in yourself, you will undoubtedly hire the wrong person.

much like my father she was. She was mildly depressed all the time, though she could burst out with brilliantly timed hilarious commentary. Her at-

titude was one of subtle disdain and "holier than thou". Intuitively I always felt that her behavior was masking a deep insecurity. Edwina behaved like this with the other employees and with me. She was just sour. I always felt that if I just loved her enough, gave her enough positive support and good strokes, she would blossom.

Edwina worked for me for three years and I never felt comfortable with her. I could feel how competitive she was with me and how she just did not like me. My relationship with Edwina mirrored the unsatisfactory relationship I'd had with my father. As I had not come to peace with my relationship with my father I was playing out my unresolved issues with a person who reminded me of him. I was doing this unconsciously. Until I became conscious of the unresolved pattern being mirrored in the dynamic with Edwina I could not change it. I was a victim to the unhealthy relationship dynamic.

I appreciated her phenomenal talent and her excellent work habits ~ she never missed work, was dependable, and she could literally create anything ~ a true artist. Best of all, everything she created sold. She had an inherent sense of what the customers wanted. The amount of what she sold never fully compensated for the toll her personality took on me and the rest of the staff. She just was not worth the dollars she brought in, for the anxiety she created. When you have one person on your staff who doesn't like you and does not treat you with respect, you must remove that person from the system or you have a smelly situation on hand.

Firing her was the single most empowering act I did for myself and my business in all those years. It was the day that I could say to myself that I, personally, and my business, professionally, was worth more to me than the fantasy belief that I could change someone from being sad to being happy. As I had worked out some unresolved issues with my father in an appropriate setting outside the business arena, I no longer needed to unconsciously play out that dynamic with Edwina.

Working consciously on my emotional blocks helped me to make a

healthy decision for myself and my business. By letting Edwina go from the shop and my life I stepped into my role as healthy leader of my business and my little world.

In my heart I always would love her, the beautiful person I saw inside of her, her essence. In my sanity and clarity I could finally see that the beautiful core essence of her person was the not the personality I, and the rest of my staff, had to deal with on a daily basis. I got out of fantasy and into reality.

> *The day that I valued myself and my business more than I valued the notion that I could make it better for someone else was the day I truly reclaimed my power.*

The day that I valued myself and my business more than I valued the notion that I could make it better for someone else was the day I truly reclaimed my power.

That day I made decisions not from an emotional wound but from my emotional strength and clear thinking. That day was a huge breakthrough day for me in my battle with codependency. That day I won.

PRIESTESS PEARL OF WISDOM

Your business and the intimacy of the relationships that develop there present the perfect opportunity to expose emotional wounds. When you run your business from your emotional wounds you will not be making decisions that are best for your business. Nothing will bring these wounds to light as much as the family of origin unconsciously created in the group dynamic of a work situation.

The "family" of the workplace can reveal dynamics that may be keeping you from being in your healthy power. The Priestess Entrepreneur takes the opportunity to transform patterns of disempowerment into true self-empowerment by identifying and confronting the way she uses her own power. Healthy use of power comes about when one is able to be entirely true to one's inner self and allows others to be true to theirs.

The Priestess Entrepreneur understands her role as "Mother" and strives to heal her own wounds so she may be a strong leader and role model as a healthy, empowered woman. The Priestess Entrepreneur understands that until emotional wounds are addressed she runs the risk of running her business from an unconscious, disempowered stance.

Only in a truly self-empowered state are you able to make the best and most effective decisions for the success of your business.

CHAPTER
8

BOUNDARIES
Your Second Skin

Eight

In the context of self-empowerment and emotional health, healthy boundaries are prerequisites for running a successful business. Healthy boundaries are physical and/or emotional limits that you set for yourself.

Having a healthy boundary is like having healthy, intact skin.

Healthy boundaries protect the inner functioning of your physical and emotional being. Healthy boundaries protect you from other people getting too close, emotionally or physically, psychically or mentally. If someone is too much in your space, in any way, your integrity can be threatened. When your integrity is threatened you will make decisions from a defensive stance, rather than from a place of centeredness and empowerment. With healthy boundaries in place you are free to function from a place of power and self-assuredness.

You have to create healthy boundaries from within and maintain them from without. Just as a wound on your skin can invite infection and disease into your body, so do inappropriate boundaries invite emotional disease to enter your consciousness.

Consciously choosing to create healthy boundaries for you and your business sets you solidly upon your own path of freedom. Your business will reflect how clear you are in your boundaries and your limits. You set your own parameters for your own comfort and optimum functioning.

THE POWER OF SAYING "NO"

Learning to say "no" is the key that opens the door to your freedom. Saying "no" gives you time to decide. Saying "no" gives you breathing space. Saying "no" gives you time to think things out. Saying "no" gives you the option of not committing to something you might not want, giving you the option to say "yes" to what you do want.

If you are a people pleaser (and what nice girl isn't?) learning to say "no" when you mean "no" is THE absolutely most important thing you can learn to do for yourself.

Learning to say "no", when you are used to saying "yes" when you mean "no", is a life practice. It's called being true to yourself. Once you are called to walk your path of truth, you will be challenged constantly to stay true to yourself.

> *Having a healthy boundary is like having healthy, intact skin.*

You will be challenged daily, moment to moment, until you become so sure of yourself and your beliefs that nothing can challenge your strength and commitment. The Priestess Entrepreneur says "no" when she means "no" and "yes" when she means "yes".

PHYSICAL BOUNDARIES ~ PERSONAL SPACE

Personal space is how much space you need around yourself to feel safe and in control ~ your physical comfort level. You usually learn your own personal space comfort zone by the culture you are raised in, the environment of your life experiences, your emotional life experiences and your nature. Whatever your personal space boundaries are ~ you NEVER have to apologize for them ~ ever.

My hairdresser does not like to be hugged by people unless she knows them really well. She told me that many of her clients want to hug her and

she does not feel comfortable with the hugging thing. One of her clients told her that she has "intimacy issues". I suggested that perhaps she didn't have issues, she had preferences. Thank goodness we have preferences and we can make the choice to express them. Just because everyone else is eating and enjoying chocolate does not negate, in any way, your enjoyment of vanilla, thank you very much.

Know what is right for you and stand by that. Knowing yourself and what feels right for you is baby step number one on the path to conscious empowerment.

DON'T OVER EXPLAIN ~ YOU'RE FINE AS YOU ARE

If you are confronted on your behavior, never get defensive, just tell your truth. Whoever is asking can take it or leave it.

It is not your responsibility to get someone else to approve of you. It is only for you to approve of yourself.

Act in a way that feels respectful and kind. Treat others how you like to be treated.

I have found that the truer I am to myself and my

If you are a people pleaser (and what nice girl isn't?) learning to say "no" when you mean "no" is THE absolutely most important thing you can learn to do for yourself.

feelings of self-respect the more I am treated that way by others. If you cannot imagine how it would feel to be treated with utmost respect, find someone you admire whose behavior and demeanor you enjoy. Practice that way of being until you naturally feel that way too.

EVEN A CUSTOMER CAN CREEP YOU OUT ~ DO YOU REALLY NEED THAT SALE?

Inappropriate boundaries can come from a customer, especially in retail or any personal service type of business. Sometimes a customer would take a particular interest in me or one of my staff. If I, or a staff person, felt put off, threatened, or personally uncomfortable with someone, we let that person know that we were not interested. I was never above calling the police, if I had to, to keep a customer at bay. I did have to call the police on a few occasions and I am glad that I did. Never allow a situation to escalate to where you feel threatened, physically or emotionally. Take action to neutralize the situation, or call for appropriate support.

> *Know what is right for you and stand by that. Knowing yourself and what feels right for you is baby step number one on the path to conscious empowerment.*

ASSERTIVENESS TRAINING ~ A GOOD INVESTMENT

If you do not feel good about asserting your power should you need to, take an assertiveness training class. You will learn much about your own power. At least you'll learn that you have the power to decide how to handle any potentially threatening situation and neutralize it before it gets out of hand. Being smart is your best and most dependable tool — street smart. Awake, aware, conscious.

EMOTIONAL BOUNDARIES ~ EMOTIONAL WOUNDS

Physical boundaries are fairly straight forward, as they are concrete, physical and tangible. The more challenging boundaries to maintain are the emotional ones, the ones that protect your feeling states. Emotional boundaries

are more difficult to identify as they are more subtle, sometimes protecting your ego and sometimes protecting the unconscious. If you are emotionally healthy, emotional boundaries provide the skin which guards your integrity. If you are emotionally unhealthy inappropriate boundaries will trigger your emotional wounds.

Healthy boundaries allow you to identify an emotional wound and keep it in safe keeping at the workplace until you can address it appropriately in a therapeutic setting. Unhealthy boundaries leave emotional wounds open for invasion by unhealthy intruders ~ your own doubts and illusions of unworthiness and other people's wounds and agendas. Unhealthy boundaries leave you feeling vulnerable, setting the stage for inappropriate, and potentially damaging, decisions and behaviors.

> *It is not your responsibility to get someone else to approve of you. It is only for you to approve of yourself.*

If you do not identify and shine the light of consciousness on your wounds, you will run your business from your wounds, rather than from your power.

The gift of identifying your wounds, by letting yourself feel and identify when someone is pushing at your emotional boundaries, gives you the opportunity to heal those wounds.

IDENTIFY INTRUSIONS

The first step in gaining your power around your boundaries is to be able to identify when someone is approaching your emotional boundaries. You will know this is happening because you will feel physically uncomfortable. Perhaps you will start to flush, or sweat, or get a stomach ache, or your voice will rise in pitch or volume, or you will feel meek and withdrawn. You need to learn to notice these changes in your physical body. They will be the

physical triggers for you to know that your emotional boundaries are being threatened, kind of like your own personal smoke alarm. You know how good you feel when you have a smoke alarm hooked up ~ you sleep better. It's the same thing when you are able to identify the triggers to your boundaries being invaded. You can get the hell out of there before your whole house catches on fire.

Remember that your boundaries are like skin. When your skin gets goose bumps it is experiencing a temperature change or an emotional response of excitement, fear, or recognition. It starts to turn bright red if you are having too much sun. Just as the skin warns the body that adjustments need to be made to maintain equilibrium, your body will tell you if your emotional boundaries are being triggered and that something needs to be adjusted to maintain your emotional equilibrium.

> If you do not identify and shine the light of consciousness on your wounds, you will run your business from your wounds, rather than from your power.

You know right away when something is asked of you if you want to say "no". You will always get a feeling in your gut when something is not right for you. When you get that feeling it is completely up to you to admit to yourself that you are having that feeling and that feeling means you need to say "no". So say it.

FAKE IT, 'TIL YOU MAKE IT

Years ago, before I had my shop, I had a business partner in a freelance design business who was a master in speaking her mind and standing up for herself. She often shocked and sometimes appalled me with her forward, bold style. I wouldn't have dreamt of speaking my mind as she did. But I learned from her. I incorporated her bravado into my style, when I needed it.

When I was frightened to speak up for myself or to speak out on something I believed, when everyone felt differently than I did, I would make believe that I was she. I would take a big breath and just…say it! To my shock and disbelief, no one knew that it wasn't me speaking. No one knew that I was scared to death. They thought I was the person speaking my truth and they were fine with it. And really it was me ~ the new me who was learning how to speak out. Learning by imitating, "fakin' it 'til I was makin' it".

In my shop, when the staff was confronted with a difficult customer, I would tell them to make believe that they were me, say what I would say. They did, it worked, and they learned some of my speaking out ability that I learned from someone else. Find your role model and emulate her until you find your own voice. I promise you, you will find it ~ it really happens ~ with practice.

REPEAT PERFORMANCES ~
WHY IS THIS HAPPENING TO ME AGAIN?

In an ideal world, when you are completely healed, you would be able to go about your business and everything would flow smoothly. Your days are filled with all good things and you feel intact, complete, safe, and productive. Until that day arrives most of us are dealing with emotional wounds from our childhoods being

> *The key to creating successful boundaries is to be awake and aware to the power you have to make your life experience exactly what you desire.*

played out in our businesses. If you have not worked on the healing of these issues they will come up again and again for you to confront. There is no way around it.

143

Every time you say to yourself: "Why is this happening to me again? Why is this person taking advantage of me again?" ~ these are the trigger statements that show you that you are perpetuating a pattern. If you are experiencing it in your life, then you are creating the experience as an opportunity for you to work through a wound and heal it.

The key to creating successful boundaries is to be awake and aware to the power you have to make your life experience exactly what you desire.

If you find yourself in repetitive patterns of experiences that leave you feeling victimized, disempowered, or frustrated, you need to look at the choices you are making, consciously or by habit, which are creating these patterns.

For me, there were two repetitive theme patterns that emerged periodically. The themes went like this:

- I want everyone to like me
- I want to be seen as a "good" person

These two issues, and all their convoluted cousins, led me down endless tangled paths. These issues were the cause of much hassle, hurt feelings, financial losses, and general poor decision-making. Until I could identify these issues and address these wounds consciously, I was running my business from my emotional wounds. I bled emotional goo all over the place, poisoning the business, and myself.

I WANT EVERYONE TO LIKE ME

Wanting everyone to like me is a set-up for disaster. It is never going to be a reality and who would really want it anyway? If I am in my true power it is only important that I like myself and that I am living by the standards I set for myself. If I like myself I will attract other people who also like themselves and will probably like me too.

When you come to a point where you really like yourself, competitors might come your way, but you cease to care to engage. As I heal my need to

be liked, I find I do not need someone else's approval to carry on with my life. It is only important that I feel that I approve of myself. I then attract others who approve of themselves and do not look outside themselves to validate their life choices.

GIVING AWAY YOUR POWER

Every time you look outside yourself to validate your choices and decisions you give your power to someone else, often to someone who does not have the insight and overview that you have.

No one will ever know your business as well you do.

You never want to make decisions for you and your business based on you wanting others to approve of and like you. When you are the owner of a business, you are the leader. Your decisions need to be based upon what is right for the business. When you are unclear in your boundaries and you are concerned that everyone likes you, you will often make decisions that are not in the best interest of the company.

When you make decisions based upon someone else's approval it's as if you are sitting in the driver seat while letting the passenger drive.

HOW BOUNDARIES GET PLAYED OUT IN THE BUSINESS ARENA

Firing an employee ~ Talk about not being liked!

An excellent example of where being liked can get in the way of good business is when you have to fire someone. Firing someone is one of hardest things that any boss has to do. It's one of those things that, as an owner, almost guarantees will make you feel that the people you're firing will not only dislike you ~ they'll despise you. In a heartbeat you go from being "good" Mommy to evil Stepmother.

The experience of firing an employee provided me with the potent opportunity to work on feeling and maintaining my healthy boundaries. It

was usually fairly obvious when an employee was ready to move on. I hated to be the one to have to point out the obvious. Firing someone always challenged me because I did not want them to dislike me.

As part of my hiring agreement I stated upfront that that when an employee felt their time was up at the flower shop, she need only say so, and she would be released from her obligations. I never wanted anyone working for me who didn't want to be there 100%. I didn't want their "I don't want to be here" energy in their work. People who no longer wish to work for you will act out in many ways, usually by not working while they are on the clock, which is most annoying, not to mention being bad for the morale of the other employees.

How you choose to handle the firing of an employee is directly related to how fully you are in your power. The less empowered you are to make right, healthy choices for your business, the more traumatic the firing experience will be. The responses of the employee being let go will be indicative of where she is in her on emotional healing path. Be prepared for anything.

Francis ~ Authority Issues

Francis was an argumentative, bickering type of a person. She questioned every direction I gave her. I found her to be difficult to work with; we were a bad match. She was a natural plant killer ~ too many plants were dying from overwatering during her brief stay at the shop. No matter how many times I patiently explained plant care to her, she seemed hell bent on drowning the poor things.

> When you make decisions based upon someone else's approval it's as if you are sitting in the driver seat while letting the passenger drive.

I questioned myself incessantly, confronting myself as to why I could

not properly teach her to care for the plants. I blamed myself for her inability to learn proper plant care. Finally I considered that maybe I was not at fault, but that she was a poor employee for my little shop. I decided to let her go. She was appalled and furious at me for firing her.

She was the first person I ever had to fire. She told me that working for me was like working for a dictator. Needless to say I cut that conversation short. If she felt that way about me you'd imagine she'd have been thrilled to get out of there ~ pronto. Francis obviously had some "issues" with authority. Luckily for me, because I consciously empowered myself to let her go, this employee's "issues" would no longer be worked out in my shop.

Marianne ~ Hysteria and an over-involved Mother

Marianne, who was in her late twenties, had been co-owner of a shop elsewhere before she moved to my town. She misrepresented her skills and aptitudes and was unable to perform the jobs that I had hired her to do. She was resistant to receiving direction from me as she was used to being the boss.

Though I could see all the things that were not happening in Marianne's job performance, I questioned myself, not trusting what I could plainly see. I thought perhaps I wasn't being reasonable, that I was expecting too much. Finally when I faced the fact that I had to re-do every flower arrangement that she had made before it left the store, I admitted to myself that I had to let her go. I rearranged her designs for two weeks straight before I could face having to fire her.

When I let her go she cried hysterically and asked how I could do such a horrible thing to her. I attempted to explain why I felt it was better to let her go and she just wouldn't hear any of it. She verbally attacked me and accused me of all kinds of heinous acts against her personally. I explained to her that she was a natural leader and perhaps she could consider going into business for herself. I pointed out to her how she was not doing the jobs that I hired her to do at the level that she said she could do them and that I felt she misrepresented herself to me. She finally left in a rage. A few days later I received

a very emotional telephone call from her mother. She accused me of ruining her daughter's life, crushing her confidence, and destroying the innocence of her sweet child. I did not take their outbursts personally. I let them vent their anger and frustration, while sticking to my decision to let Marianne go, as I knew it was the best decision to make for the shop.

Well, wouldn't you know it? The next year Marianne opened her own shop. After I sold my shop, one of my designers went to work for her. Through the designer I learned that Marianne admitted that she could understand now why I made the decisions I had made. Marianne, from her new vantage point of owner, could now understand the owner's perspective, which is oftentimes different from that of the employee.

The Priestess Entrepreneur makes decisions that are in the best interest of the business, not of the individual employee.

Being ultimately understood and forgiven, as it were, is a nice feeling, but certainly not to be expected. And, of course, it does not matter at all. You have to do what is right for you and your company. Whether the employee can understand or not is her path, not yours. Your responsibility, and challenge, is to be as clear and uplifting as possible. When you let someone go it is never o.k. to be punitive or hostile. You can work that out on your own, by screaming in the car at the top of your lungs or any other form of non-abusive release of feelings.

The Priestess Entrepreneur makes decisions that are in the best interest of the business, not of the individual employee.

Keeping a needy employee on too long

Monica was a fantastically talented woman, but was much more of an artist than a retail flower designer. Her displays, though beautiful, were com-

pletely impractical for a retail space, because all the items, which should have been for sale, were part of her "piece". She was too flamboyant, showy, and artsy for my little shop. She also had the primadonna drama thing going, always flying into the shop late, with some dramatic tale of woe to share. I knew I needed to let her go because she was not a "match" with the energy of my shop. I struggled over this decision because she was a single mom and had just moved here from another state. She was in a financial crisis and emotionally unstable. I felt bad for her and felt that the store was a safe haven for her. I let my personal feelings for her personal life situation get in the way of making a good decision for the shop.

I finally set her free from the confines of retail and though she cried, because she needed the job, she knew I was right. She thanked me and told me that was one of the most inspiring firings she had ever had. No doubt she went on to working at another job which served her needs better. I had no business thinking I could "save" her by having her work at the shop. I only created havoc and drama at the shop and prevented her from moving on to her next destiny.

DONATIONS ~
THEY'LL PUSH YOU RIGHT TO THE EDGE

When you own a business you will be called every day to donate money or in-kind services to every worthy, and not so worthy, charitable cause. When you get caught in the "I want to be seen as good person" syndrome, you will be tempted to commit yourself to every call for help. If you do that you not only will go bankrupt, you will not have one bit of energy left for your business.

Requests for donations will push you to decide which organizations you will support. Ideally you need to come up with a plan for giving. You will need to come up with a dollar amount that you are able to give, on a monthly or quarterly basis. If you are donating in-kind services, you need to calculate how much money that is really costing you.

For instance if I decide to donate flowers for a community event I need to calculate not only the cost of the flowers, but also the cost of the labor involved in creating the donation. The combination of the cost of product and labor will be what the donation is really costing your company. Give wisely.

When a donation is requested of you, inform the person requesting that you will consider their request. NEVER give an answer immediately over the phone that might commit you to something you're not quite sure you want to do. This is where you get to practice saying "no", where saying "no" buys you time to decide. Someone else's need does not necessitate you trying to make it all better for them. All you can do is to consider their request. If it fits your budget and you want to support their cause, do it. If not, you will have the chance to tell them that your donation quota is full; perhaps you can help them at another time.

> *Decide what you can give and how often, and then stick to your plan.*

In my community I received a lot of requests for donations for private schools and church groups. As a general rule, with an occasional exception (if I knew the person or if they were good customers) I would not donate to private institutions or religious groups. I would offer discounts, but I did not donate to them. I got so many requests from so many different ones, none of which I belonged to myself, that I decided to donate only to causes that I supported ~ like the food drive for needy families, the humane society, and other non-profit community oriented groups.

I learned to let myself feel that I was a "good" person by only donating to causes that I believed in and that were uplifting my community in a way that was synchronous with my own beliefs. You have to figure out what those are for you and give in a way that feels good to you. Just because

someone asks you for a donation, does not mean you have to give. They are asking; you can choose how and to whom you give.

Do not give the store away. If you give the store away there won't be a store any more. Do not give out of guilt or obligation. Some giving can be written off as a promotion cost, but you need to check with your accountant to be clear on that.

Decide what you can give and how often, and then stick to your plan.

It's about Time

We all know that Time is a concept that we humans have construed to help us create some sort of order in our lives. If you ask your dog what time it is no doubt you'll get one of the following answers: "Time to eat, time to go out, time to play, or time to go to sleep". Ah... they have a good life, those dogs. Ask a business owner that same question and you'll get answers relating to task completion, appointments, and deadlines.

We use Time to keep us all relatively on the same page. In a business, Time creates the format for the day, for the week, for the month, for the year. Pretty much everyone has joined the consensus of what Time is and how it can serve us best. Time is always an issue in business, specifically more so if you don't have your own head on straight about our how you do Time in your life.

The Early Boss

I am a compulsively early person, the nightmare of any of my employees who were not. I have actually tried to train myself to be on time, and not always early, but I find it nearly impossible to do. It's easier for me to be early, have a book in tow, and relax peacefully waiting. I am constitutionally unfit to be tardy in any way, shape or form. Being the baby of four, I never wanted to be left behind. I always made sure I was ready before anyone else so there would be no question as to if I would be left behind ~ I wouldn't be!

WHAT KIND OF A TIME PERSON ARE YOU?

It is helpful and interesting to look at your own attitudes about Time and how your family related to Time. Your attitudes and relationship with Time will be acted out in your business. As you can imagine, I had zero comprehension or tolerance for lateness. Unfortunately for me I did run into quite a few employees that had issues of being late. I tried all sorts of tactics and ways to help them be on time. A very small handful of employees who had lateness issues ever adjusted to my needs. Eventually I had to let the late types go, but not without a fight and uncomfortable feelings all around.

In my business lateness just never ever would work. Unlike in an office type situation where there is somewhat more leeway, a retail shop opens at a certain time. Employees are expected to be there in plenty of time to open the shop. When we had events to service we also were expected to be on time ~ early if you were me.

Surrender to the needs of the business not to the needs of the employee.

I finally learned and surrendered to my own needs about my staff being on time. In the final years of hiring I stated outright that they were allowed to be late once, barring a true emergency (I determined what an emergency was and what was not. If it was a true emergency, they were to call in). If they were late more than once they would be fired. What happened was that I weeded out "late types" right at the hiring interview. The more clear a prospective employee was about my expectations, and on what I was not willing to negotiate, made for much better and satisfying hiring.

Your business should always be feeding you as much, if not more, than you are feeding it.

Like in a love relationship, don't get involved thinking you're going to change another person. You are NOT ever going to change anyone. They

might change if they want something bad enough, but it might not happen in your lifetime ~ and don't bet on it. If you cannot tolerate tardiness, then don't hire someone who thinks your Time policy is strange and don't keep someone on board who cannot respect your Time policy. It really is as simple as that.

PRIESTESS PEARL OF WISDOM

How you create boundaries for yourself can make or break your experience in business. When you feel good about yourself and create healthy boundaries you feel that your business is working for you. When you do not create healthy boundaries for yourself you will tend to run your business from your emotional wounds. When you run your business from your emotional wounds you will find that you are working for the business more than the business is working for you.

Your business should always be feeding you as much, if not more, than you are feeding it. If not, check out how you are creating and managing your boundaries ~ physically, emotionally, mentally, and spiritually.

Healing your emotional wounds and creating healthy boundaries for yourself will set you on a path of emotional freedom, making for a much more enjoyable and successful business experience. Healthy boundaries set you free to ride the road to your own success, in every sense of the word.

CHAPTER
9

I'd Really Love This Work
If It Weren't For the Customers

Nine

The opportunity of customer service lies in the question it poses: "How committed are you to work from your sense of your conscious self-empowerment?"

When you are tempted to give your power away to a customer, you may lose track of your core values, experiencing yourself as victim to forces beyond your control. The Priestess Entrepreneur uses her strong, centered self-empowerment to get the most out of customer service, using potential challenges to enrich and support her commitment to her spiritual growth.

When you commit to being in your power, customer service is a pleasure. When you give customer service from your centered, self-empowered stance, you are able to give good service, regardless of what is presented to you. There will be customers who are easy and appreciative and others that will be challenging and demanding. By standing true in your own center of clear thinking and commitment to your core values, the challenges that inevitably arise in customer service will not throw you off balance.

Customer service provides endless opportunities for you to find your center and stay there.

Your core values and belief in your business will keep you on track. Customer service can be trying, as it requires you to show up in the most conscious and aware way. The more conscious and committed you are to providing good customer service aligned with your own core values the more satisfaction and success you will experience in business.

Once I realized that I had a daily active arena in which to play and practice, choosing the high road of customer service became my commitment and my goal. I did not recognize this right away. I learned it over time as I became committed to having my place of work be my place of peace and spiritual practice.

In a warped and distorted way the customer can develop an illusion of power over the business he uses wherein he can believe that he has a right to abuse the staff of a business. It's like when you are a pedestrian you despise all who drive. Likewise when you are driving you hate all pedestrians. Somehow in our little selfish brains, we may forget from minute to minute that we are pedestrian and driver, customer and server. Nothing hones the spirit and gives more opportunity for personal growth than working with the public.

> *Customer service provides endless opportunities for you to find your center and stay there.*

GOOD CUSTOMER SERVICE IS ABOUT GOOD NON-EGO INVOLVED LISTENING

As sole owner and manager I had to deal with and confront any and all potential problems that arose. Being the owner means that you are ultimately and completely responsible for everything that goes on in your business.

The first years in business were extremely challenging because I was so attached to my creation that I couldn't stand any complaints or conflicts at all. I was living under the illusion that the customer was always right, as I had been taught.

It isn't that the customer is always right, it is that the customer is never wrong.

In negotiating a problem with a customer it is never good practice to

blame them or in any way make them wrong, as that will always work against you. On the other hand, you don't have to be wrong either. As soon as you get the Ego involved in the settling of a dispute, both of you lose. The goal in the care and maintenance of your customer base is to get to the bottom of what would make the customer happy, and try to give that to the customer to the best of your ability, within reason. "Within reason" is the operative phrase here, and it is a very nebulous state, depending on the situation. The trick is to handle problems and complaints consistently with as little Ego involvement as possible, creating minimum loss to you and your business and maximum satisfaction for the customer and for yourself. The customer needs to feel that she is heard, her complaint is noted and appreciated, and that you are doing everything in your power to satisfy her requests.

Your customer wants to be heard, acknowledged, and then appeased in some concrete way. Sometimes just being heard is enough. Sometimes nothing will ever be enough and you have to know when and how much you can do and when to say "Enough!"

You have to learn to decipher when a customer complaint is reasonable, wherein you can make a difference in the situation, and when you need to let the customer go. It is true that an unhappy customer will tell many more people about an unhappy retail experience than a satisfied customer will tell about a positive retail experience. In the long run you have to stay committed to your own values and some sense of reasonableness.

> *Being the owner means that you are ultimately and completely responsible for everything that goes on in your business.*

I think what happens in business is that we are vulnerable and available to anyone who might be having "issues", which might or might not have to do with us. This is the first thing you have to figure out: Does this complaint have

anything to do with us? If it does, what can I do to remedy the situation?

We had a lovely sign up by the register explaining our return policy, but we still had to explain all too often about the fragile and ephemeral nature of a fresh flower and the ramifications of neglect and improper care on plants. In the case of fresh flowers educating the customer as to which flowers last longest, how to care for the flowers en route to their destination and how to care for them once they're there, is enough to assuage a customer's dissatisfaction with natural vase life. Oh, and of course, I'd send them home with a few new flowers, both to show that there are no bad feelings and I'd like them to try again.

Green and flowering plants were another story all together. When a customer complained: "It died" really meant "I killed it". Realistically I should be the one to be angry, which I often was, saddened at least, when a perfectly fine and healthy plant was *It isn't that the customer is always right, it is that the customer is never wrong.* taken home and was either burnt by the sun, tortured by under or over watering, or no watering at all, and generally neglected. My policy was that I would not replace a plant unless it was returned to the shop in less than a week and was sporting some infestation that it probably was harboring all the way from the greenhouse, just waiting for inferior growing conditions to blossom fully into a problem.

HANDLING COMPLAINTS ~
BALANCING REASON AND INTEGRITY

My return policies were generally not up for negotiation. I developed them over the years after I saw the patterns of returns and complaints. My staff knew the policies, and unless the customer was too difficult to please, they handled all complaints themselves. Returns were never given in cash form,

store credits only. The only time I refunded cash was if I saw the customer was entirely unreasonable and I was choosing to no longer continue a business relationship with them. Here's your cash back, end of story.

Most complaints that came through the flower shop were fairly legitimate and easy to fix. We were always respectful and considerate, giving the customer the benefit of the doubt. We were never confrontational or in any way punitive, though I have heard of service staff responding that way to a complaining customer and to that I say, "Bad Form!" You always have to feel good about how you handled a situation, regardless of how trivial or grand it might seem.

In the big picture, as you work towards creating a consciously empowered life for yourself, how you handle any problems, tiny to huge, will very much affect your peace of mind.

Gentle, but firm, fair and professional behavior that when reviewed at day's end elicits the response "I handled that well" is the only sane way to go. Any other response means you still need to work on your ego involvement.

Over time, I came to realize that every contact with a customer was an opportunity to work on my own spiritual growth. My personal goal became to uplift each customer, to have him leave the shop not only feeling better about his flower shop experience, but feeling better about himself and his ability to make his world a better, more peaceful place. The flower shop was a great place to practice my self-empowerment and my desire to not take other people's issues personally as my own. A formidable challenge, at best, but I was determined to make my job one that uplifted my own spirit as well as those of my customers and staff.

> *You always have to feel good about how you handled a situation, regardless of how trivial or grand it might seem.*

THE PRESENTING PROBLEM VS. THE REAL PROBLEM

Minor incidents like dying flowers and an occasional dead plant were mere glitches on the screen of customer service. The real challenges occurred when I was dealing with subtle, behind the scenes, issues that had nothing to do with the presenting problem. The presenting problem is the obvious complaint like: "the flowers died" whereas the underlying complaint is "I hate that the flowers died and I'm afraid I might have killed them but I feel so bad about my lack of nurturing ability and my badness in general that I'd rather believe that you sold me inferior flowers so I can blame it on you and not deal with the fact that all things die and I cannot stand the death thing" or "I am so tired of being ripped-off in this world. I am tired of paying for something, then having it not work and have no one listen, care, and that what I bought is faulty. The flowers dying are the last straw. Replace them, refund my money, or I will hack you and each of your employees to death with my cell phone!"

To win the customer service game you have to feel really good about how you handle your customers and yourself. You have to be able to say "Ah, I had such a good day. I handled everything well."

It is of utmost importance to acknowledge the presenting problem while simultaneously being able to understand, have compassion for, and address the underlying complaint. If you can address both levels of the problem by your response, you are truly hiking the high road of customer service. And really, if you are not going to play the game to win, why play?

To win the customer service game you have to feel really good about

how you handle your customers and yourself. You have to be able to say "Ah, I had such a good day. I handled everything well."

GIVE THE CUSTOMER WHAT SHE REALLY WANTS ~ TO BE HEARD

Let's talk about some real life scenarios at the flower shop.

I always responded to the "it died" presenting problem with my in-depth talk on how to care for fresh flowers and plants. I would share my knowledge warmly and invitingly, never from a punitive stance. I spoke with my customers as I liked to be talked to at the hardware store. Frankly, I am idiot supreme at anything that requires tools. I like to be addressed in an informative way without the salesperson speaking to me as if I were from another planet, but rather as an interested person who had no knowledge of tools. Period.

I spoke to my customers with respect for them as human beings, and just because they didn't know about flowers, did not preclude them from wanting to know. In fact, if they were in my shop they obviously were interested in flowers... what an opportunity for me! If every person I talked to that day left the shop with a greater appreciation for flowers, I had done a good job that day. I wanted to uplift others by enhancing their appreciation of flowers. All other issues were fluff to get through to this objective.

I spoke in peaceful tones, giving the person my complete attention. I looked them directly in their eyes, making them feel, with my attention, that they were the most important person in the world, which, for that moment, they were.

To be totally and completely present for someone in the moment that you are conversing with them is the greatest gift you can give someone, a gift much grander than a good sale and a good purchase.

When a person left my shop after meeting with me, he knew that for a few moments he was the most important thing to me. I trained my staff with that philosophy, reminding each of them frequently, that for some

people, their time in the flower shop would be the very best time of their day, perhaps of their week. If we each had the opportunity to brighten a day, we were contributing to the greater good in a meaningful way.

Managing complaints of a more serious nature, ones that you receive by phone or by letter, have to be dealt with based on the same philosophy but in a grander and more centered way. A more intense complaint presented in a more attacking way gives you an even greater opportunity to live your philosophy of strength through peaceful negotiation, staying in your power, and being consciously alert. A more confrontational complaining style will push you harder to maintain your cool and to keep appropriately detached while still listening to the presenting problem, identifying the real problem, and then deciding what and how you will deal with it, if you can.

COMPLAINT BY MAIL

Receiving a complaint in letter form is easier to handle than a phone call. The phone call is 100% emotional and the chances of tempers flaring, voices rising, and unkind words being exchanged are much more likely to occur. Be thrilled if a complaint comes in letter form.

I received a letter expressing a woman's rage over the flowers her beau brought home to her, relating his experience at the shop. I could not respond to the choice of flowers he took, because I

To be totally and completely present for someone in the moment that you are conversing with them is the greatest gift you can give someone, a gift much grander than a good sale and a good purchase.

didn't know, but I definitely knew what his experience at the shop had been. As I knew that the quality of flowers at my shop were of the highest, I could

only theorize as to why she was so enraged and I knew intuitively that it had nothing to do with us, only very peripherally, as pawns in her drama in her relationship. Let me elaborate.

Her beau came in to the shop late on a Friday afternoon. Every Friday we ran a special where many of the flowers could be purchased two for the price of one. It was always wildly busy, in a totally fun and extravagant way. We always had beautiful music playing and there was a warm and wonderfully welcoming feeling in the shop, even more than usual. My staff was comprised of some the nicest and most polite young women I have ever known. Each and every one of them working up front on a Friday afternoon was someone any customer would be thrilled to have serve them.

Chances are this customer came in, was greeted, and was told that someone would be with him shortly. Perhaps he would like to look around a bit. The shop was 1500 square feet and there was always plenty of space in which to mosey about. It was hardly what you would call a place that was in any way unpleasant in which to wait to be served. When his turn came, he was served, and he left. The staff, when later questioned about this customer, told me that he seemed pleased when he left the shop, if not a little bit in a hurry, but who isn't on a Friday afternoon? This is what we witnessed on our end.

Probably what happened when he arrived at his girlfriend's was somewhat of a different story. According to her grievance letter he complained to her that he had had to wait SEVEN, that's right, you heard me correctly ~ SEVEN minutes until he was served, horrified at that imposing experience on his evening. She did not at all like the flowers that the salesperson chose and she felt they were completely overpriced. She informed me that she was absolutely disgusted with our flowers and our service and that not only would she and her beau NEVER shop at my store again, she would be telling everyone she knew. Since she lived in the neighborhood right near our shop she hoped that would affect many of our customers, and ruin our business.

That seemed a fairly extreme response to a flower purchase. Whatever was the scenario that played out at her house, the fact that the letter was written that very night, seemed to suggest that the emotional response was way out of proportion to the actual events. I wrote back a very polite and caring letter. I expressed my sadness that she was not pleased with the flowers and that her friend had not been pleased with the flower shop experience. I sent her a $15 store credit and invited her to come in on a Friday so she could partake of our Friday specials. I did not send the store credit because I thought we were wrong, or that I thought he or she were wrong. I sent the store credit because I wanted the woman to know that I, for one, heard her, and that I would like her to have a good experience at the shop, if she chose to do so.

I responded to her complaints in a hand-written note. She could see that I took the time to write to her and that I was personally responsible. As it was my shop, I wanted to personally invite her to return. Even though she wrote to me in rage, I did not respond to her rage, but to her underlying sadness. She did come in and use the store credit, and I hope it was a better experience for her. I never heard another word about it.

I felt that I had handled the situation in a way that was aligned with my values. I did not want to make her wrong. I wanted to hear her complaints and assuage her hurt feelings, if I could. I took the high road, and I felt good about it. I turned a negative experience into a positive one for me, and hopefully for them as well.

TAKING THE HIGH ROAD ~
GET OUT OF THE EGO REALM

You can always transform an experience by taking the high road. By choosing the kind path of customer service you uplift the world, one opportunity at a time. Putting yourself on the line, presenting yourself as responsible, diffuses the energy of even the most extreme situation.

Kindness and a sincere, attentive response will always win over an emo-

tional response. Whether the customer joins you on the high road or not is their choice, but it wouldn't be for you not choosing that path.

The important thing is for you to walk the highest path, respectful and responsible. You can never be responsible for someone else's response, only for your own. This is not to say that you don't have your own processing to do behind the scenes. Of course you do, that's what your own personal, spiritual path is all about.

> *Putting yourself on the line, presenting yourself as responsible, diffuses the energy of even the most extreme situation.*

If you had already learned it all, you wouldn't be on the front lines. You'd be retired, or dead.

Processing can come in many forms. Usually it is best to talk the problem out with a trusted friend, fellow business owner, counselor, or a staff member. What you are trying to do is diffuse an emotional response to get to a higher level of responding in a spiritually aligned way that is congruent with your true inner Self's beliefs. An emotional response is usually the first response as it is controlled by the Ego, who loves to hog the stage. Once you can diffuse the energy of the Ego you are clearing the way for a more resonant response.

Sometimes it is best to let the Ego have its way a bit. You can go in the bathroom and have a little scream, or crying jag. You can get in the car, turn the radio on full, and scream at the top of your lungs. You can compose a nasty letter of response, which you do not send, but rip up or burn. You imagine all the things you would like to say if you were functioning from your Ego. You curse and whine, and flail about a bit. Then you laugh, because you remember it's all a game, and an opportunity for you to turn lemons into sorbet.

Once you get in the habit of allowing the Ego its spoiled child response

the Ego gets tired, knowing you won't be taking it seriously, and soon you can go immediately into spiritual response and skip the Ego response step all together.

In my early years in business, upon receiving a letter like the one I mentioned in the previous section I would probably have pronounced out loud quite a few distasteful choice words and wrote off the whole letter as some hotheaded woman who wanted to soil the good and nice name of my business. I undoubtedly would have taken the letter entirely too seriously and would have fretted and worried about it for days. As I matured and learned to choose to respond from the consciously empowered realm, on my highest path, I chose to deal with the letter in a kind and effective way. Once I sent my letter back to her, I felt good and clean about the situation and could thoroughly enjoy the rest of my day.

> *If you had already learned it all, you wouldn't be on the front lines. You'd be retired, or dead.*

WHEN THE CUSTOMER COMPLAINT IS COMPLETELY VALID....OOPS!

Sometimes the customer's complaint seems out of proportion and sometimes the customer is right and you need to buck up, take responsibility and stomach the consequences for your own behavior. These are the circumstances in which you are given the biggest opportunities to grow, sublimating your Ego along the way.. These challenges are no fun, and they are not easy.

If you deal responsibly and cleanly with a problem situation you will only have to do it once. If you don't, the same issues will keep coming up again and again, until you get it right.

To deal most effectively with any problem in business it is best to work

from the Love realm, not from the Ego realm. The Love realm is oftentimes an unfamiliar realm, because it is the realm run by the highest self and not by the Ego. The Ego hates to do the Love lessons, because the Ego never gets to participate, only the highest self does.

The Priestess Entrepreneur handles ALL problems and complaints from the Love realm. In the Love realm, everyone wins. In the Ego realm, no one wins.

THE WEDDING NIGHTMARE THAT WOULDN'T END

I need to preface this story with telling you that when weddings are mentioned to anyone in the service trades you will notice the subtle twitching and sweat that comes over the person. Weddings are a potential nightmare for all service providers because they are so inherently fraught with emotion and pressure for perfection. Every wedding is a perfect set-up for anything, and everything, to go wrong. The expectations are so high; there is hardly any way you can get around something going wrong.

My friend, the caterer, says that at each event one

> *If you deal responsibly and cleanly with a problem situation you will only have to do it once. If you don't, the same issues will keep coming up again and again, until you get it right.*

of the service providers ~ the caterer, the photographer, the florist, and whoever else might be involved in creating "the most important day of our lives" ~ will take the brunt of any imperfection of the day. You can only hope and pray that it is not your service being provided that "ruins their lives forever". But sometimes it is.

Over time I've learned to chuckle about all this. I think that if they can't get through the wedding together, how in the name of all that is sacred, are

they going to survive the marriage? Ha! But, of course, you can't say this to the bridal family. You just have to get through it and pray that it all goes well.

On this particular Thanksgiving weekend I was the one that "ruined their lives forever". Gives you a bit of a powerful feeling, except that it's untrue. It's just the family's projection of the lack of perfection in the universe that you get to carry and then hopefully fix for them ~ Good Luck!

In October I received a call from a prospective bride. She was calling from out of town and was to be married in my town the weekend after Thanksgiving. Intuitively I felt I should not do the event because I knew that I would be understaffed that weekend due to the overstaffing I would have had to have done for the Thanksgiving holiday preparations. Even though I had a bad feeling about it, I felt the shop could use the sale to boost the entire sales for the holiday season. Always trust your intuition; this time I did not and lived to regret it.

The bride told me that they would be bringing evergreen wreaths that they would be making themselves and all I needed to provide for the table

decorations was to decorate the wreaths in a very minimal way. She described miniature roses and red pepper berries. She told me the wreaths would be no more than 10" in diameter and they would be supplying the candles to place in the center of each wreath. She told me that they would be in town Friday before the Saturday wedding and they would drop the twenty wreaths by at that time.

The couple arrived late Friday afternoon with many large plastic bags. When I saw the size and quantity of bags I knew that the wreath project was not going to be as simple as they had told me it would be ~ oh, and it never is.

The first mistake I made was to have them open the bags of wreaths at the front counter of my shop. I should have brought them into the back

room. In my exhaustion from the holiday and my resistance to decorating some unknown quantity I was very curt with the couple. When they opened the bags and showed me the wreaths I was horrified at what I saw. The wreaths were completely misshapen, unattractive, and well more than twice the size the bride had said they would be.

My first response came from a point of panic when I realized that in order to make the centerpieces into pieces that I would feel comfortable putting my shop's name on, I would have to reconstruct each wreath and go to the wholesaler by 7 a.m. the next morning (a 40 minute drive to Denver and 40 minutes back) in order to get enough materials to decorate the wreaths appropriately and in time for the early afternoon event. I panicked when I saw the breadth of the project. My own perfectionism would not allow me to let those wreaths go out in the lumpy way they came to me, nor could I let them be sparsely decorated. I let my panic and exhaustion dominate the exchange with the couple and I spoke some harsh words as to what I would have to do, at the last minute, to remedy the situation. I also said that there was no way that I could do the work for the amount that I had quoted them on the telephone. Since I would have to reconstruct each wreath and double the amount of materials that I would need to decorate them, I had undercharged them by half. Then I looked at their faces.

They were so horrified at my outburst and were so dejected that immediately I realized I put a real bummer onto their wedding celebration and I felt very badly about that. The groom's face looked so crestfallen. The bride told me that he had made those wreaths himself from trees on their property. I told them that I would handle everything and that since I quoted them a price, let's just leave it at that. It was a bad feeling all around. They left the shop.

In thinking about it later I realized that:

I should have given a price quote that was a range and that we could come up with a set price after I had seen the wreaths.

Since I did not do that on the phone....

I should have held my tongue, worked within the price we had decided upon, and allowed the wreaths to be as they created them and most importantly...

I should have listened to my intuition and not taken on the wedding for a weekend I knew I would be exhausted because it only got worse from there.

I called the bride at her hotel about an hour after they left the shop. I apologized profusely and sincerely for overreacting to the wreaths. I explained that I was just tired but that I would be fine on Saturday and I would take care of everything and there would be no extra charge. She was very forgiving and offered to pay more for them. I felt so bad about my behavior that I insisted that she just pay what we had originally agreed upon. My bad attitude and mouthing off cost me $500. I asked her also to apologize to the groom and she said of course that she would. I also sent my driver over with a small vase of flowers for her room as an apology.

The next morning, in the freezing dawn of November in Colorado, I went to the wholesaler, picked up all the extra things I thought I would need and got back to the store by opening time at 8:30 a.m. I went into high production mode and completed everything about an hour before the wedding needed to be delivered. Everything was beautiful, just perfect, or so I thought.

A staff person delivered the personal flowers to the church and everything else to the hotel for the reception. About an hour later I received a phone call from the father of the bride telling me that they only received two bridesmaid bouquets, instead of the three that were ordered. I felt completely sick to my stomach. I grabbed the wedding order form and saw how I had misinterpreted the instructions and yes, three bouquets had been ordered, and I had made only two. Fortunately I had enough ingredients there on hand to construct another bouquet, in some record-breaking time, and had my staff person bring it to them at the church. The lone third bouquet made it for the wedding ceremony but not in time for the formal photographs ~ one empty-handed bridesmaid.

By this time I was so upset I was shaking, even though I had done all

that I could do. Now I just wanted to go home and drown myself in the bathtub. Ah! there was more to come.

A few weeks later I received not one, but two letters from their family. One was from the father of the bride, and one was from the father's sister, the relative who lived in town and had recommended me as the florist. You can only imagine how painful it was to be brought to task for what I already knew to be a mishandled situation. The reprimands were scathing. I was accused of destroying what was to have been the happiest day of their lives. No one was sorrier than me. I wrote the dad a letter of apology and sent him some money back. With the extra flowers I purchased and the extra time and travel it took me to do the event and all the people I had to hire to assist me ~ I basically gave them my work for free.

In response to the aunt's letter, which was even more punitive (she felt responsible as

> As soon as you choose to engage Ego to Ego with another person, you are sliding off the high path and you will crash.

she had recommended my shop) I explained that I had already refunded some money to the dad and then I explained bit by bit what happened. I wrote her a four page letter because her underlying theme was that I had not cared about her niece's event and that hurt my feelings. I explained to her why I did what I did and that I did everything with good intention. I also sent her a store credit so she could come in and get some flowers for herself. It was a long and tedious process. But when I sent the letter off to her I was done. There comes a point in any conflagration where you have to expose your humanness and take it from there. I felt I handled the series of mishaps and misbehaviors as best as I could, so...enough! I never heard from any of them again.

If I had it to do all over again I would follow my initial intuition

and say that that weekend was already booked. When you know you have erred, even with the best intentions, make amends verbally and monetarily, sincerely from the Love realm, and move on.

The stories go on and on, as they do in any customer service business. The complaints range from absolutely valid to inappropriate distortions of the Truth. You can be made to be a saint and bringer of all things good and beautiful to being the devil incarnate and being the ruin of lives from that day forth. Every day you have the opportunity to stay true to your own power and your own sense of what is true and right for you. The greatest opportunity you will ever have to work on is your commitment to hike the highest path is customer service. Embrace the opportunities, take them on, do the best that you can, and then go home at the end of the day, look at yourself in the mirror, and say: "I handled that well."

Every day you have the opportunity to separate from the dramas of everyone else's life. Stay solid on your path of peaceful living through knowing yourself and your business and staying true to that. As soon as you choose to engage Ego to Ego with another person, you are sliding off the high path and you will crash. The more you stay committed to the consciously empowered path, the better a view you will always have, the fresher the air, the more peaceful and empowered you will be.

DON'T DEFEND YOUR FEES ~ EDUCATE YOUR CUSTOMERS

It is always a challenge to offer a service and have someone pay for it. Even though it is the basis of running a business it still is challenging. There has to be agreement between what you feel your products and services are worth, determined by the going rate and what someone will pay for them.

Flowers, being a hands-on product, like grocery store items, are usually understood to sell for certain prices, which the customers have been used to paying. Selling flowers as part of an arrangement gets into a whole other field of pricing, and one that is often misunderstood by the customer. As

soon as you are arranging flowers in a container you need to factor in the cost and mark-up of the container, any materials used to accent the design, the flowers themselves and the labor it costs to create the design. So, in a design that sells for $50, there may only be $30, or less, actual cost of flowers. As these other costs are "hidden" costs, except for the vase, it is often misunderstood by the customer.

For instance, all the greenery that is sold as accent material to enhance the look of flowers has to be purchased by the florist just as the flowers are purchased. Nothing is free. Because many people are used to getting flowers with "just some greens thrown in" they get irritated with having to pay separately for items that used to be included. That's the way it is though. If you are trying to run a profitable business, you cannot be giving away things ~ not material, and not labor.

This is the opportunity to educate your customer. It's like eating at an upscale restaurant, where every item is sold à la carte. Though you are paying more for the food you also know you will be receiving the freshest food, prepared by a trained chef, and served to you in a fine fashion. You are paying for a full experience, and you will pay more than you will pay at a drive-through fast-food establishment.

Never apologize for your product or service ... educate!

The same theory was behind the flowers I sold. My flowers cost more than at the supermarket because I hand selected them at the wholesaler's in Denver, paid staff to process them individually, I displayed them gloriously, I had meticulously trained staff to wait on people and design arrangements, and a huge overhead to cover all this care and service. When a customer complained about the price of flowers I never felt that I needed to apologize ~ just that I had the opportunity to educate.

Most people do not have any idea what it takes to grow a flower for

commercial sale, process it, market it, then sell it to the wholesaler who then sells it to me, who then processes it, markets it, displays it, and sells it to you. I always felt it was my opportunity to educate people on how those flowers got to be in my shop. That way I expanded their understanding of the business of flowers and increased their appreciation of the industry. Customers could then understand why a certain flower costs what it did. It's all in the education, not in taking personally why a customer might think something was too pricey.

Often my young staff would be insulted when a customer scoffed at the price of a flower. Logically one can see how absurd it is to take personally such a thing. But

Nothing will challenge you as much as customer service.

we are sensitive beings and we often over-identify with what we sell so that what we sell becomes a reflection of ourselves. Once again that is the needy Ego rearing its ugly head.

Of course what we sell is not a reflection of who we are. If a flower costs a certain amount, it just does, and that is no reflection on if we are a good or bad person, or if we are running a good business, or not. I taught my staff to educate themselves and the customers so they never felt like they needed to defend the product, but to present the products in all its worth and wonderment.

Never apologize for your product or service ... educate!

PRIESTESS PEARL OF WISDOM

Customer service can become the most fertile training ground for spiritual practice. Every day you will be challenged to live your highest truths and be faithful to walking your highest path. Nothing will challenge you as much as customer service. Everyone who serves the public knows this. How you choose to work it for your own, and the planet's, highest good is completely up to you.

At the end of her day, the Priestess Entrepreneur can recline in her scented bath and say "I handled that well, graciously, fairly, and professionally." Well of course you did, you're a Priestess!!

You can let people ruin your day, or you can make each day a wonder of enjoying the human experience. Customer service is the opportunity to practice peaceful negotiation, making no one be wrong and everyone feel like they have "won". It is the daily opportunity to turn potential battle into joyful co-creation of a positive, enlivening experience.

The bottom line is that you don't have a business without customers. It's all about customers, and how you relate to them. There will be good customers. There will be customers you like so well you wish they'd ask you over for dinner. There will be customers whose sweetness and sincerity will

177

melt your heart. And there will customers who try your patience to its very limit. Each one of those customers is just a person, like you, trying to get through the day as best they can. Make their day and your own ~ enjoy every moment of it.

When you no longer want to do customer service, change your line of work, but don't take it out on them. Customers are your best teachers, for they will push you to be the best person you can be.

Allow your needs and desires around customer service to evolve and change over time as you do. Take the high path of spiritual business by being honest and true to yourself. What you cannot do yourself ~ delegate ~ or change your line of work altogether.

The Priestess Entrepreneur handles all customer service challenges from the realm of Love and with a hefty sense of humor. She remembers to look at the big picture, that each potential conflict provides her with an opportunity to elevate herself in her self-empowerment, an opportunity to take the high road of peaceful negotiation and resolution.

At the end of her day, the Priestess Entrepreneur can recline in her scented bath and say, "I handled that well, graciously, fairly, and professionally." Well of course you did, you're a Priestess!!

CHAPTER 10

Making Decisions ~
Who is Driving Your Bus?

Ten

*Y*our business is an extension of you. How you make decisions for your business is often the same way you make them in your personal life. Making business decisions and, either enjoying or suffering their consequences, shows you exactly where you trip yourself up and where you flow in your decision-making process.

Most people make decisions in a combination of styles. The more aware you are of what your decision-making styles are, and what circumstances bring them out in you, the more you will be able to make adjustments according to the needs of your business. To be flexible, having as many choices available to you as possible, is the best way to do business, and Life.

MAKING DECISIONS EMOTIONALLY ~ TERRIBLE IDEA!

The most challenging aspect of decision-making for women in business is the unconscious pattern of making decisions emotionally. Because women tend to be caretakers and tend to nurture their businesses as they would their families, it is easy to fall into the pattern of making decisions based upon pleasing others as opposed to choosing what is in the best interest of the business.

When you make decisions for your business based upon pleasing others you are making emotional decisions, which is like having the passenger, not the driver, drive the bus.

Think of your business as a bus and you are the designated driver of that bus. The more aware you are of how you are making decisions for the navigation of your bus, the better a ride it will be, adjusting and accommodating to your desires, so as to be most aligned with where you wish to go and how you wish to get there. If you are making decisions emotionally, which are mostly unconscious choices, it is like someone other than the consciously empowered you making those decisions. It is like having the crazy person riding in the passenger seat directing your bus. Who knows where then you will end up?

When you make decisions for your business based upon pleasing others you are making emotional decisions, which is like having the passenger, not the driver, drive the bus.

The *emotional you* is incapable of making the correct decision for your business. The *emotional you* does not have all the facts and cannot make well-rounded, sane decisions. The *emotional you* can only make decisions from its limited and dramatic perspective, which is clearly not how you wish to make decisions for your business. Making decisions emotionally is fraught with so many pitfalls that the more you are aware of your tendencies to do this (if you do), the more able you will be to separate what could be emotional choices from what would be sane and practical choices.

LOIS RUNS HER BUSINESS EMOTIONALLY

Here is a good example of an emotional choice, obviously made without the best interest of the business in mind.

Lois runs a small Feng Shui design consulting business out of her home. She hires a young girl to run her office. The girl decides to go through all the drawers of the desk, organizing to her preferences. Without consulting

Lois, she tosses out many tools and papers that Lois would have liked to have kept. Lois only finds out about the tossed items when she goes to look for them. Lois is very angry because not only is the cost to replace these items not in her budget, but more so, because her employee took it upon herself to discard Lois's things without consulting with her.

Many larger items are disappearing from Lois's workroom. She cannot prove that her employee is stealing them, but she and the girl are the only ones with access to the workroom. The sane decision would be to talk with the girl, and should the situation not change, let the employee go.

When Lois finally confronts the girl Lois knows the girl is lying to her but she feels badly for the girl because the girl is new to town and has no money and no support. She keeps her on for a few months, losing more inventory and merchandise as the weeks go by.

Lois's feelings for the girl, and her desire to take care of the girl, whom she perceives to be in a vulnerable position, and who reminds Lois of her own daughter, clouds her vision as to what the right thing is to do for her business.

Lois's decision to keep the girl employed when she knows the girl is stealing from her is an emotional decision and one that is clearly detrimental to her business.

HOW TO TELL IF YOU ARE RUNNING YOUR BUSINESS EMOTIONALLY

We have all made decisions based on our emotions, even if we know they are not made with the best interests of the business in mind. We make these decisions from our feelings. The best way to know if you are making a decision based purely on emotion is to run the situation by another businessperson. Get some feedback from a person you trust and who is able to call you on your behavior, even if you may not want to hear it.

Sometimes you will choose the emotional decision anyway, even if it is not the best decision for the business, but because it just feels good to you. You AL-WAYS have choices. Make your decisions with a clear and self-aware mindset.

DO YOU RECOGNIZE YOURSELF IN ANY OF THESE STYLES?

The procrastinator

The procrastinator will always put off to another time that which needs to be dealt with in the moment. The double downside of procrastination is that not only does the problem you are avoiding not get addressed but also...you feel terrible about it. Minor procrastination is not too difficult to handle. Eventually if you get irritated enough you will do what needs to be done. Extreme procrastination can drive you, and everyone who is affected by you, nuts. Procrastination can cripple you and your business.

Catherine has an employee who is chronically late. Her tardiness puts stress on the other employees, who have to pick up the slack for her. The employees have told Catherine of their problem, of which Catherine is wholly aware herself. Catherine has very poor confrontation skills when it comes to her employees. She hates to reprimand them in any way, wanting to accommodate them, putting their needs above the needs of the business. She puts off telling the late employee, irritating the rest of the staff and compromising the flow of her retail business.

The more she avoids talking with the tardy employee, the more irritated the rest of the staff becomes, making for a more and more uncomfortable work environment for every one.

The staff becomes so irritated with Catherine's inability to take control of the situation that they start to talk about her behind her back, to each other, and to the customers. She is quickly losing the respect of her staff and her customer base is being threatened.

A procrastinator will say to herself:

" I will deal with that annoying tardiness problem tomorrow, the day after tomorrow, next week, when I have the time, when I feel better, when I feel up to it, when my head is clear, when I......"

Impractically spontaneous

The person who makes decisions in this style gets so caught up in the entice-ment of the moment she does not think of the long-term consequences.

Marsha is shopping at the fresh flower wholesaler. It is Friday before Labor Day weekend. Most of her regular customers will be out of town for the weekend. The wholesaler is having a huge sale on all its fresh flow-ers, because all if its customers will also be out of town for the long weekend and they want to move their product.

> *You ALWAYS have choices. Make your decisions with a clear and self-aware mindset.*

The roses are so pretty and ooh!! all the colors available and they are so inexpensive! Marsha buys ten times the amount of product she could possibly sell because she is so caught up in the moment.

Marsha's ability to make a healthy decision for her business is ham-pered by her delight in getting such a good deal. This short term vision impairs her ability to think ahead to the fact that she will not be able to sell the product, she just knows she wants to buy it.

There is nothing wrong with a healthy dose of spontaneity as long as it is backed up by practical business sense. If you make your decisions based entirely on spontaneous, visceral response without heeding sane, practical business practice you set yourself up to deal with the consequences of your impetuousness, which often will make a direct hit to your pocketbook.

The methodical plodder and plotter

At the opposite end of the spectrum from the spontaneous, impulsive deci-sion-maker is the person who plots and plans and calculates only to drag their feet in implementation. Plotting and planning are fabulous precursors to action, as long as you actually commit to, and take, action. Good busi-

ness sense combines the instinct of appropriate timing in conjunction with thought-out planning and practical plotting.

Maureen wants to sell her business. She writes endless lists of its selling points and why she feels she needs to move on in her life and let go of the business. She has itemized every asset of the business and its worth to a potential buyer. She has created an elaborate business plan with good financial projections and ideas for the future growth and expansion of the business. She never actually puts the business up for sale, even though she has plotted and planned and thought it all out. It never becomes a reality.

All the planning in the world won't get you anywhere unless you take action to implement the plan. It's like writing endless recipes for dinners you actually never cook.

The incessant questioner

The questioner is an information gatherer. She accumulates as much information and opinions from as many different sources as she can access, always believing that what someone else knows has more validity and applicability to her business than she might inherently know herself. What might work for one person might not work for another. One business might not be comparable to another, and often is not. Information gathering is useful but is not the end-all and be-all of decision–making. You have to be able to discern which information is appropriate and directly applicable to your business and which is superfluous and should not be used.

The main drawback of gathering information from other people, specifically their opinions, is that the other person is always, by default, telling you what is real and true for them, which often has nothing to do with you and your needs at all, best of intentions notwithstanding.

Candace lives in a community where most of the businesses are owned and managed by families. Candace is a sole proprietor of her business, a dog-grooming business she has started from nothing, with no financial backing from her family or a lender. Everything that her business is today

is from her own work, her own creative financing, and her intuitive natural instinct for doing good business. Candace is a natural lone eagle sole proprietor type; she has run her business alone, in her own way, and wants to keep things that way.

Candace often asks business advice from fellow business people. Most often she receives advice that would presuppose that she had a husband or partner upon whom she could fall back were the plans not to work out. All the information she spends time gathering is appropriate to a family-owned business and not to a business run as she has successfully run hers.

Candace gathers so much information that she has a difficult time discerning what is applicable to her business and what is not. Candace has troubling trusting herself and her own instincts as to what would work for her unique business. Ideally one collects information and then filters out all that does not apply, using what does. The problem is that it is often hard to tell which information is appropriate and which is not. There is always something to learn from listening to other people's stories, but it is never to be taken as being right and true for you unless it feels that way. The more you learn to trust yourself and your ability to discern what is right for you, the more other people's stories become enjoyable, but not necessary, for you to move forward in your business.

The agonizer

Agonizing over decisions can be a direct corollary of too much information gathering and the tendency to procrastinate. The agonizer is often a person who does not trust her ability to make the appropriate decision for her business.

Agonizing is more pronounced when a woman does not admit to herself that she knows her business better than anyone else. It also points to the fear of taking full responsibility for whatever becomes the outcome of a decision. Agonizing stems from fear of failure, fear of making a mistake. If you are afraid that your decision will bring trouble you can agonize yourself right into just not making a decision at all. Agonizing maintains the feeling

of being always on the fence…ouch!!

The agonizer's cry is "What if? What if? What if?" What if, indeed. The paralysis of non-action that comes with agonizing creates a self-fulfilling prophecy of failure. Agonizing creates lost opportunities. If you cannot choose, decide, and move on, you surely will fail!

Josie owns a restaurant/café in a building that just became available for purchase. She agonizes so long over the decision to invest or not, that the opportunity passes. A group of investors buy the building and double her rent. She is forced to relocate because she can no longer afford the overhead. She lost not only her place of business but also the potential tax shelter the building would have provided and the opportunity to sell the building in the future making her money back, and so much more.

The point and choose style

This style is like taking a multiple-choice test in a language you don't know. It's like playing pin-the-tail-on-the-donkey in full blindfold. Point and choose means that you have gathered no information, made no considerations, that you will just try something out and see how it works. It's like choosing a surgeon out of the telephone book.

This is a particularly ineffective style as it puts the responsibility of outcome on the luck of the draw. Decision-making in this style can become very expensive as the outcome is completely unpredictable.

Georgette needs insurance for her retail business. She picks up the telephone book, opens to the yellow page listings for insurance and calls one, any one. She does no comparison shopping, she asks no questions. She orders the insurance and goes on about her business.

She did not know that she chose the most expensive company, with the fewest benefits to her business. Her laziness and "it's all the same to me, choice a, b, c, or d will do" decision-making style costs her business hundreds of dollars in unnecessary costs. Just picking and choosing…you might as well be blindfolded! Who's the donkey now?

The self-flagellator

This is the person who constantly reviews decisions already made and feels that she has made the wrong decision. She continually goes over choices she could have, and should have, made and how those choices would surely have been better choices than the ones she did make. This is like driving forward and looking only in the rear-view window to see where you have been and what is now behind you, wishing you had turned off at an exit that is long passed.

The self-flagellator lacks trust in herself and her decisions. The time spent chastising herself for decisions already made would better be spent learning from decisions perceived to be poor so as to insure better decision-making in the future.

Elena has a gift shop in a strip mall. On Thanksgiving Day the bakery, the coffee shop, and the liquor store have decided to be open until 2 p.m. She is so tired and has already let her employees make plans for Thanksgiving, giving them all the day off. She drives by the strip mall about noon and sees many people gathered around her store window, obviously looking to buy her wares. She rushes in to open the store for a few hours, chastising herself mercilessly for being lazy and not being open all morning. She goes over and over in her mind of how much income she could have brought in had she been open in the morning. She scolds herself for being tired and for letting her staff have time off when they could have been there bringing in revenue. She is so miserable thinking about the morning business missed that she cannot enjoy her afternoon off, fretting the day away.

Irresponsible non-chooser

Some people become so overwhelmed at the prospect of having to make decisions and holding themselves responsible for creating the experiences in their life that they just choose not to choose. Non-choosers remain victims of what they perceive to be circumstances outside themselves, never stepping up to the plate to claim their own power. The course of their life

experience is always somebody else's fault, someone else's doing.

Lorraine closed the doors to her retail business over a year ago. She has not opened one letter of correspondence since that day. She has never declared bankruptcy, never contacted any of the vendors to whom she owes money; she just never deals with any of what needs to be addressed when one closes a business for good. Lorraine really set herself up for disaster because unless she dies before it comes down, she will have to face the music eventually and it will not be a pretty tune.

Lorraine is so overwhelmed by the consequences of her failed business venture that she just stopped dealing with them altogether. She just turns a blind eye and hopes eventually the letters will stop arriving, which they do not.

To be a victim is to be an observer of your life, not a full participant. The less you take responsibility for your choices and non-choices, the less fully you are living your life. A business run by an owner who is a victim can never grow to its full potential or barely to any potential at all. To let the pieces fall where they may completely disavows the owner of any power to make changes or to have a different experience than what the winds may blow her way.

Cosmic, not conscious

Far be it from me to question what may appear as divine intervention, miraculous events, and mystical unfolding. I am a great believer in much of what cannot be seen or proven. I do know that one can pray and chant and light candles and still one must show up and do the work.

I am all for whatever gives you hope and sustains you in your belief that all will be well, but it is all meaningless if you do not show up and do what needs to be done to make your business successful. All the prayer in the world will not make a bit of difference if you are not taking responsibility for your business and what occurs there on a daily basis. All the prayer in the world will not clean the floor if no one is assigned to do it and bills will not

be paid unless you are bringing in the income to cover those bills.

Olivia was beginning an import business of crystals. She invested most of her available funds into the gems. Her garage was full of beautiful specimens. She was out of money and needed to sell a lot of the crystals just to cover her bills for the month. She decided to have a sale out of her garage. She told a few friends and sent emails to the list of people who were already customers of her interior design business, people to whom she had already sold crystals. She did no other advertising. She prayed and believed that the Universe would support her in her crystal business, that people would come and purchase enough merchandise to completely cover her bills. The day of the sale, a few people showed up, all friends, and no crystals were sold. All the prayer in the world will not work half as well as a well-placed ad in your local newspaper.

Eventually Olivia's commitment to her cosmic, not conscious, practical thinking led her down a path to bankruptcy, for her business and for herself personally.

PRIESTESS PEARL OF WISDOM

How you make decisions for your business will be similar to how you make decisions in your life outside the business. The more aware and conscious of your decision-making style you are, the more power you will have to make the right decisions, i.e. the decisions that best serve the needs of the business and your needs as owner.

Beware the tendency to make business decisions from an emotional stance. If you know that you are prone to this style of decision-making, get help. Learn to utilize sound judgment and healthy information-gathering to make decisions that move your business forward and support you in your integrity as owner.

The more honest you can be with yourself about your capacities as decision-maker for your business the more empowered a decision-maker you become. Self-awareness and brutal self-honesty is the only sane path to managing yourself as THE decision-maker of your business, driver of your own bus.

CHAPTER 11

Good Bartering Makes Good Sense

Eleven

perfect place to try out your boundaries is when you decide you want to do trades, or barter, for services. To barter means that you do not exchange monies for product or services, but choose to trade your services/products for someone else's services/products.

Trading can be a wonderful marketing tool and it can keep the energy flowing without exchanging cash.

Attribute a value to your products and services.

Use that value as units with which to barter.

Handled properly, bartering can be a mutually beneficial where everybody goes home feeling that they got the best end of the deal. That's if it's working well.

KNOWING THE VALUE OF YOUR PRODUCTS AND/OR SERVICES

First and foremost assign a monetary value to your goods and/or services so you know clearly what it is that you have to trade. For my business I devised a complicated trade system because I couldn't trade flowers straight across the board for what I paid for them as I had to pay to get them to the shop, have them processed, arranged and then delivered. I also did not feel comfortable charging my full 3.5 markup, as they were to be used as a marketing expense as well as a trade for services and products. I came up with a flexible exchange, depending on the situation.

HOW I WORKED MY TRADES

If the person I was trading with came to my shop and took their flowers with no arranging (just wrapped) I gave a higher value than if I had to arrange and deliver the flowers away from my shop. I never traded on orders that were sent out of town, through another florist, as that was too pricey for me. I decided what I would trade and what I would not. I assigned value with which I felt comfortable. This ensured a fair trade agreement. I learned that if I was starting to feel uncomfortable I needed to change the trade so that it worked for me, or I needed to cancel the trade altogether. If it got too out of balance, sometimes I just paid the person cash and completed the trade that way.

LEARNING THE HARD WAY

My very first year in business I developed a trade with a person who created my brochure for me for my design school part of my business. The trade began in September. We never discussed any part of the trade except the value. I had not even decided, at that time, what markup I

Attribute a value to your products and services. Use that value as units with which to barter.

would be trading my product, because honestly I never even thought about it. I also never clarified what in the store would be available as part of the trade, which I didn't realize at the time, would be a problem — but turned out to be.

The graphics person came in about ten days before Christmas and wanted to use her trade. Before I knew it she had chosen many of my specialty items, hand-created permanent floral pieces, to give as gifts to her friends and families. At that time I had just been in business for less than 3

months and every piece of inventory I had in that tiny little shop I needed to be able to sell for Christmas, just to break even.

I was very upset with that trade. I was such a novice I didn't even know how to say that she couldn't use the trade in that way. Because we hadn't agreed up front what the parameters of the trade would be, I really shafted myself. We ended up negotiating somewhat and I recovered some of my losses. It is always best to set up the trade so that there are no losses to recoup!

A better trade for me would have been to create limits on what items she could and could not use as part of the trade and set up a reasonable timeframe in which to use the trade value so that it did not leave me in a bind. Perhaps I could have limited the trade to just fresh flowers, which were a low-labor item for me and easy to obtain. I could have stated in our agreement that giftware items and hand-crafted pieces were not included in the trade. By not creating a trade agreement that worked for me I felt taken advantage of and ripped off.

POOR COMMUNICATION CAN LOSE YOU A LOT OF MONEY

Trades are often the source of much frustration and the cause of bad feelings due to lack of a clear, mutually beneficial agreement, wherein the involved parties are unclear as to the value of their goods and/or services. This lack of clarity can lead you down a difficult path of feeling being ripped off or, at the least, unappreciated. Worst case scenario is that you really are ripped off and you don't want to do business with that person, or business, ever again.

It 's good practice to check in periodically with the people you're trading with, perhaps at the time when you are reevaluating the trade, and ask if the trade is still working for them. Too often people are dissatisfied with a trade relationship but they are afraid to bring it up for discussion.

Take it upon yourself to keep open and truthful communication flowing.

Never assume the status of a trade relationship – always ask.

Don't avoid dealing with the communication around a trade agreement.

It is always preferable to clear the air and keep the lines of communication open than to feel uncomfortable.

LISETTE ~ POOR TRADE AGREEMENTS

Lisette owns a skin care clinic. She traded skin care treatments with a photographer, called Jane, for her engagement and wedding photos. Their agreement was that Lisette would perform a series of skin treatments for Jane at the clinic over a designated period of time. The agreement was that Lisette herself would perform the treatments. Lisette made the agreement that way because she was running her clinic under a very strict budget and would not be able to trade either products or treatments from other technicians because she could not afford to pay out of pocket for any of the trade. If Jane took product or treatments from anyone but Lisette, that would have created too much cost for Lisette.

> ᛉ Take it upon yourself to keep open and truthful communication flowing.
>
> ᛉ Never assume the status of a trade relationship ~ always ask.
>
> ᛉ It is always preferable to clear the air and keep the lines of communication open than to feel uncomfortable.

Problems arose because though Lisette knew what the parameters of the trade were, she neglected to explain the details to her staff and Jane was less than honest in her use of the trade. While Lisette would be out of town on business Jane would schedule appointments with other technicians,

buy products, and buy gift certificates for some of her own customers with the trade ~ all of which were outside the agreed upon limits of the trade.

Lisette remedied the situation, but not until after some financial damage was done, not to mention the loss of good faith. She could have avoided all of the hassle if she had had a clear trade agreement written up, signed by Jane, and had informed her employees as to the rules of the trade so that nothing could slip by.

Prevent the mess from happening in the first place so you don't have to clean it up afterwards.

Be CLEAR in your communication.

THE EASY TRADE

When there are no products involved, just services, then you are dealing with a more straight forward situation. Each of you knows what you charge by the hour, or by the session, and you can trade straight across the board. For instance, Paul is a psychotherapist and Peter is a body worker. They trade hour for hour, or session by session. If Peter receives an hour of psychotherapy, then Paul receives an hour of bodywork.

Prevent the mess from happening in the first place so you don't have to clean it up afterwards.
Be CLEAR in your communication.

Sharon is an acupuncturist, Delia is a gardener. Delia does three hours worth of gardening, valued at $20/ hour in exchange for one session of acupuncture, valued at $60.

TRADES ARE EXCELLENT PROMOTIONAL TOOLS

When I was in my Leads group (see the marketing chapter and the part on

networking groups) I did a lot of trades with the members in the group. Because most of us were new in business it was a really effective way of getting the word out about our work, without having to exchange cash. Having flowers to trade was much to my benefit. I could trade pretty much for any service with a trade of flowers. For my business this was a particularly excellent trade. I put my business card on every vase of flowers I had out there, plus a stack of business cards piled by the vase for my weekly orders. I had a perfect avenue for marketing my products as flowers do all their speaking for themselves. I received a tremendous amount of business through my Leads group this way.

Simple Guidelines for Bartering

1. The trades must be completed within the fiscal year. Your bookkeeper will be happy about this, as will you.

2. The trades are to be used only for the persons agreed upon and designated at the beginning of the agreement.

3. The trades cannot be used as gifts for another person, unless that is understood between both parties.

4. Comprehensive up-to-date accounting must be kept so as to avoid any confusion. Keep a receipt for each transaction so that clear records are being kept. It is amazing how fast everything can get away from you if you do not keep clear records. Clear record keeping keeps the transactions nice and clean for all parties involved.

5. Review your trades every three or four months. Reevaluate them in the light of the present time and what is happening realistically in your business. If you are giving away more than your business can afford, renegotiate your trades, or delete some of them entirely. If people are not using their trade with you and the trade is becoming unbalanced, inform them.

6. Decide how much cash you need to bring in to your business and how much product and/or services you can trade without creating financial loss. A trade is only worthwhile if it is.

7. Inform your employees as to trade agreements.

The Priestess Entrepreneur creates clear guidelines and communication in her trades and barters. She understands that bartering is a powerful tool for exchanging goods and services, bypassing the exchange of cash. She understands that bartering can be used as an effective tool in marketing and advertising her goods and services.

She determines the value of her goods and services, expressing this clearly in her trade agreements. She maintains clear and accurate accounting of her trade agreements. Periodically she checks in with herself and the other parties involved deciding if the trade is still mutually beneficial, and if it is not, makes the appropriate adjustments.

As in all facets of her business, the Priestess Entrepreneur is in control, making decisions that support and uplift her business and her relations with her fellow business people.

CHAPTER 12

POPPING YOUR BUTTONS ~
My, How You've Grown!

Twelve

\mathscr{B}usiness is never a static affair. Either you are growing or you are shrinking, but you are never staying the same. Optimally you want to be growing. Even if you are not growing in physical size, you can be growing in richness and depth of scope. You can grow physically by moving to a larger location or by adding on to your existing space. You can grow internally by increasing your staff so as to increase production capability or by increasing inventory to expand your merchandise choices.

Be aware of the needs of your business. Remain open to opportunities that serve your business's growth needs. Be willing to take the steps forward that promote and support growth. Undoubtedly the biggest stumbling block to forward movement and growth is fear. Fear has the ability to immobilize you into non-action. The only way around fear is through it. If you want your business to grow and mature you must be willing to face the fear of growth and do it anyway.

FEAR CAN HOLD YOU BACK FROM GROWING

Confronting your fear creates movement.

The best way to confront fear is to create support systems in your life to call upon when you are in fear. When you feel yourself caught in the fear, call your support system to talk you through, and walk you through, the fear. On the other side of fear is freedom.

Fear can look like many different things. It can manifest as rational-

izing the status quo, making non-change look infinitely more appealing than change. It can look like free-floating anxiety, which could manifest as a shopping spree for things you absolutely do not need or as sitting immobilized in front of your TV, eating chocolate truffles. I know I am anesthetizing myself from feeling when I go to the library, check out a Masterpiece Theatre series on DVD, park myself on the couch, disconnect the phone, and watch 12 episodes back to back.

Fear can present in many different forms. How does fear manifest in your life? What do you do, or not do, when you are afraid? Do you flee? Fight? Freeze? Gather with others?

As in every arena, the more you know about yourself, how you behave, and your ability to recognize your behaviors, the more able you are to have a healthy relationship with yourself, working through behaviors that show

> Be aware of the needs of your business. Remain open to opportunities that serve your business's growth needs.

that you are in a fearful state. Once you are able to recognize that you are in fear you can prepare to negotiate your way through it…always with help and support. It's like riding the river of your life. In the river of your life, fear is a large boulder in the stream. There are different ways to negotiate a boulder, depending on what type of boater you are, and the level of skill, expertise, and experience you have. The important thing is to find your personal way of negotiating boulders and use those skills and techniques when you need them.

Most fear is either concrete or emotional. Concrete fear can stem from not having enough information or training. Emotionally based fear usually stems from messages you have received from others and internalized as your own or messages you have given yourself in response

to frightening situations in the past.

RENEE'S FEAR PARALYZES HER IN HER GOAL TO CREATE A BUSINESS PLAN

Renee is a master potter who wants to open a pottery studio to serve as retail space, work space, and space to teach pottery classes. Her cousin loves her work and is willing to invest in her idea. He requests of her a

If you want your business to grow and mature you must be willing to face the fear of growth and do it anyway.

comprehensive business plan with a five year financial projection.

Renee panics. Master potter though she is, she is dyslexic when it comes to numbers. She is completely incapable of creating a financial projection for her dream business. She is so afraid to say that she does not know how to do the projection for fear that her cousin will think her too stupid to run a business at all.

She confides in a friend that she is unable to get the funding for her dream because she just cannot move forward on a particular part of the

Confronting your fear creates movement.

plan. After much talking she finally admits to her friend what she is unable to do and her fear relating to her not knowing enough to run a business. Her friend tells her of free classes offered at the Chamber of Commerce for entrepreneurs trying to get capital for their business ideas.

Renee calls the Chamber to inquire of that service. She finds a large selection of free classes and workshops designed specifically to help artists with their business plans. She attends one of the workshops and finds there

ten other artist types like herself who are requiring help in writing their business plans. She is ecstatic to find people like herself, in need of the same help.

Renee learns something much more important in her workshop than that she needs to hire a financial analyst to co-create that part of her plan with her. She learns that: It is far more stupid to not ask for help than to think you are stupid for not knowing something.

BETTY'S FEAR OF GROUPS STYMIES HER NETWORKING ABILITIES

Betty grew up in a large family. She was next to last in a line-up of six children. She was bullied by her older siblings and upstaged by the baby in the family. She learned that it was impossible to be heard in her family so she just stayed quiet. She learned to not even try to be heard. Over time she became very fearful of speaking up in school and in any type of group situation.

Betty ran a small facial and massage business out of her home. Though her work was wonderful she had a very difficult time attracting new clients. A friend of hers was attending a LEADS networking group and invited her as a guest to the group. She was so terrified to speak in front of the group that her friend had to speak for her. She was asked to speak briefly about her work, but she was unable to gather the courage to do so. She went home feeling even worse than before she had gone to the group and, of course, she attracted no new customers.

Fear can present in many different forms. How does fear manifest in your life? What do you do, or not do, when you are afraid? Do you flee? Fight? Freeze? Gather with others?

Betty's friend suggested that she see a hypnotherapist for her extreme social anxiety. The hynotherapist had helped her friend with a chronic nail-biting problem. Betty agreed to try it. After committing to some deep emotional work, Betty was able to speak in front of small groups, which she did slowly, but surely, successfully building her business to a full client load.

> *Once you are able to recognize that you are in fear you can prepare to negotiate your way through it...always with help and support.*

With help and support, from other women in business, or from a counselor or therapist, you can identify the cause of your fears and make progress towards managing them.

I am not sure every one can become fear-free. I know that one can learn to identify and manage fear so as to lesson its potentially paralyzing effect. To be completely free of fear is an unrealistic goal for most people. To be able to identify and manage your own fears, and the triggers that bring them to a head, seems to me to be progress enough.

OH NO!! I HAVE TO MOVE MY BUSINESS TO A NEW LOCATION!

One of the most powerful triggers for activating the sleeping monster of your wildest fears is to have to move your business. When you are faced with the two options of either: close shop or move, sometimes just closing shop might seem the preferable option.

After four years in my tiny, 750 sq. ft. shop I knew I was busting at the seams. The coolers were overflowing, the walls were covered with dried flower pieces, and the floor was layered with giftware and fresh flowers. I had two fulltime employees, three part-time ones, and myself. It got to the

point where we did not even have enough room to hang our coats.

On Memorial Day weekend of that fourth year in the tiny shop, I had committed to doing five weddings. That little space was full beyond capacity. The stress of not having enough space, combined with having to turn away business for lack of space, made me open my eyes to the necessity of planning a move to a larger store.

I started driving around town looking for potential spots to move my business.

I call this the "keep your options open" stage. I did not limit myself to what I thought I could afford. I let myself look with my biggest vision of what I thought I would like the store to become, what it had the capacity to grow into, given the right conditions: more retail space, good retail location with good walk-by traffic, lots of free parking and investment from an outside source.

It is far more stupid to not ask for help than to think you are stupid for not knowing something.

I was drawn to a shopping center, a strip mall, in the neighborhood by the hospital. The mall was in the throes of major renovation and regeneration. The grocery store that had been there for nigh on forty years was being dismantled and turned into 6 retail spaces. I loved the location. Being near the hospital is fantastic for a flower shop, and I loved the free parking situation. At this point I had no idea what the options and opportunities might be so I jotted down the phone number of the landlords. I was so nervous to call, filling my head with "What ifs?" What if it was already rented to a flower shop? What if there is no space there for me? What if they don't like my shop and don't want me there? What if it is too expensive?

I looked around my sweet little shop, my first shop, my baby, and had to admit to myself that I really and truly had to let it go and move on.

I had to let myself grow. I was barely able to make the call, so nervous was I to consider making such a huge leap ~ in financial overhead and in personal commitment. So I did what I always do when I am in that kind of circumstance. I made believe that this is something I do all the time and I just "faked it".

I called the landlord. She was thrilled to hear from me and said they wanted a flower shop in the soon-to-be-renovated mall and would love to entertain a business plan/proposal from me to see if we were a match.

AH!! A plan!! Of course, a written plan was just what I needed! I had a business plan from when I originally opened the shop. I dug the plan out of some box in the rats's nest I called my then office, which was in a minute corner of the shop. I adjusted the plan, adding on in appropriate places, deleting in others, tweaking the plan to the new level of growth I was considering. I hired a financial analyst to do the financial projections for me.

I'm not quite sure I really believed it would all happen, the move and all; I just acted "as if" and played along with my own little dream of going big. By the end of the week I had a plan to submit to the landlords of the mall, and to my silent business

With help and support, from other women in business, or from a counselor or therapist, you can identify the cause of your fears and make progress towards managing them.

partner, my financial investor. I hand-delivered the plan to the landlords and sent a copy off to my investor. Then I sat back to wait to hear on their verdict, which is exactly how it felt to be for me, a verdict. Would I be allowed to make business in the most desirable retail space in town or would I have to search on to less desirable location opportunities? More importantly, would my financial backer be willing to finance the

expenses of the business expansion and move?

I received a call from the landlords a few days after I submitted my plan, asking me to meet them over at the mall to discuss which space I might like to rent. WOW!!

I could hardly believe it. They said that they wanted a flower shop in the mall and the style of my business fit exactly what they had in mind. They also said they really liked my business plan. What I came to find out a few years later was that I was the only person to actually submit a business plan to them for consideration. Most of the other requests were made verbally. One request was scribbled on a paper napkin!!

I was pleased with myself that I took the venture most seriously (a paper napkin!!!!...really!) and was rewarded with the opportunity to move shop to the most desirable retail space in town. The parking alone made the space a potential goldmine.

My business partner gave me the thumbs up for the move. The landlords and I began the initial negotiations, which were particularly one-sided. As the retail space in the mall was so highly coveted the negotiation was entirely on my part. I looked over the 40-page lease with my lawyer and either I agreed to their terms, or I did not, in which case they would offer the space to someone else.

They were not up for any negotiation because they had a list a mile long of business owners who wanted their business to be moved into those available spaces. What this meant for me was to consider growing exponentially in order to recover what it would cost to move to a retail space that was under construction, one for which I would have to do the "build-out". I had never done a build-out before, nor would I ever do one again. I had no idea what I was in for, what that type of construction commitment, in time, energy, and money that would be for me. I had no clue as to the costs involved, both financially and emotionally, to make the space open for business.

In the long run I think it was my naiveté that made it all feasible for me.

I had to coordinate plumbers, electricians, builders, painters, not to mention Public Service and the telephone company. I had to be full-time contractor as well as continuing to run my business at the little shop. The process was like a problem pregnancy; it took nine months from that first call to actually being able to move in. The entire nine months were fraught with panic and uncertainty. It seemed that every day the project got more and more expensive. As I had extremely limited funds for which to make this move, the scope and excruciatingly lengthy time it took to do the build-out added unbearable pressure to an already stressful period.

I encountered every possible glitch in the construction process ~ from trying to coordinate workpeople on the job, to begging the phone company to honor their commitment to get phone service to an over-booked and under-serviced mall, to incessant rains that Spring which kept the roof work from being able to be completed. Barely avoiding a complete nervous breakdown, and tormenting all my friends and family with my near hysteria, I did finally move the shop and was open for business that Mother's Day in a huge and beautiful new space, a full human gestational period after acknowledging my need to move.

CHANGING YOUR BUSINESS WITHOUT THE BIG MOVE ~ ALSO SCARY

Sometimes you need to make a change in focus for your business without moving locations. Changing focus from what has been lucrative in the past, but is no longer workable, is an entirely different type of stress, but just as valid. Any time the need for change becomes obvious, fear can be triggered by the void of the unknown.

The same questions rear their ugly heads: Will I be able to make the transition? Will my business be viable? Will I be o.k.?

BARBARA FACES THE NEED TO CHANGE THE FOCUS OF HER RETAIL BUSINESS

Barbara ran a hippie head shop on the main street of her small college town. She had a thriving business for over thirty years. As the politics of her town became more and more conservative she felt it necessary to change the entire focus of her business. Her business partner refused. The partner felt that it had been such a lucrative business, why change now?

The business partner lived out of town and was out of touch with the changing milieu of business where the shop was located. Barbara decided to offer to buy her partner out and change the business

> *Any time the need for change becomes obvious, fear can be triggered by the void of the unknown.*

to shoes and boots, geared at the wealthy college clientele that frequented her shopping area.

Barbara was terrified to make such a drastic change. She felt stuck between two frightening choices: remain a head shop and be open to potential harassment or change the focus of the shop entirely, a risk she was not sure would pan out financially.

Barbara asked for help and support from fellow women in business that encouraged her to follow her instincts and do what she felt to be right. She did buy out her partner and is now running the coolest shoe shop in her town. The change ended up being financially lucrative to her business and she slept so much better at night ~ and we know how much that is worth...priceless!!

CHANGING ROLES WITHIN YOUR BUSINESS

As entrepreneur and businesswoman you will find yourself playing and changing roles frequently in your business. The more flexible and adaptable

you are in response to your honest feelings about what does and does not work for you and your business, the more likely you are to create changes that support growth and change in your business.

When I first opened my shop it wasn't a shop, it was a flower design school. I had never wanted a retail shop because all the retail shop owners were overworked, frantic maniacs. They had so much on their plates and worried so much I just didn't want that for myself. I thought I could teach, as I had done it before and felt that I was good at it. I thought it could prove lucrative as well.

The little "shop" that I first opened was so tiny; I never imagined that it could accommodate a real retail business. I envisioned a space in which I would teach and then in the off hours of not teaching, would run a very limited retail business.

What ended up happening was the opposite of what I had anticipated. I ended up absolutely hating to teach flower arranging. After a year I hired other people to teach for the shop. I grew the retail part of the business, coordinating classes, but not teaching myself.

The more honest I was with myself as to what did and did not work for me, the more satisfied I became with my work, the more productive and lucrative grew my business.

PRIESTESS PEARL OF WISDOM

Change is a given, how you flow with change is unique unto yourself. You always want your business to be growing and changing. Growth and change are the signs of a healthy, flourishing business. Limits to change are your own fears of change and expansion.

The more you are able to identify and claim your fears, the more chance you have of walking through your fears to freedom. The key to working with fear is to reach out for support and information. Listen to other women's paths to growth.

Be willing to uncover and work with beliefs that might be holding you back from making the changes you need to make for your business to grow and be the business of your wildest dreams.

CHAPTER 13

CARE AND TENDING
OF THE SELF

Thirteen

You will never know who your true Self is until you have experienced complete and ultimate relaxation. Ultimate relaxation can only be experienced away from all the day-to-day forces that create the life you live. If there is one phone call, one visitor, one person asking even one thing of you, you cannot know what it is to be completely relaxed. If you know you need to be somewhere to cook dinner or fold laundry after the insanity of running the day-to-day business, you cannot experience true relaxation. If anyone is expecting anything of you, you cannot truly relax.

When you have the deeply energizing experience of true relaxation programmed into your cellular memory then you are able to call upon it during your everyday life by incorporating that feeling into your daily practice of creating moments of peace for yourself. My belief is that it is nearly impossible to experience true relaxation until you experience it outside the norm of your everyday life. It's like trying to see your own eyeball with your own eye.

During the first year of having my shop, Fortune shone her lovely face upon me in the form of a woman called Gert. Gert was an astrologer and a lover of all things beautiful; she was also a woman who described herself as having won the cosmic lottery, i.e. she was extremely wealthy. Besides becoming a wonderfully emotionally supportive friend she was wildly and extravagantly generous. Gert invited me to stay with her in an exquisite hotel in a Colorado mountain resort town. She picked up the bill for everything.

It was an incredible act of kindness, and one which I appreciated in that moment and even more as time went by.

It was there at that mountain resort that I truly and completely surrendered. I released all worries and cares for an entire week. This was the very first time in my entire life that I had such an "everything is taken care of" experience. Every need or desire was just a room service call away. That week changed my life profoundly because it was during my stay there that I realized that I had never fully relaxed in my entire life and that I loved the feeling. For the first time that I could recall I could hear my deep, inner voice. I was flooded with fabulous creative ideas for my business and for my life. I realized that I wanted to create a lifestyle for myself wherein I could afford to pamper myself like this periodically, so I could access the joy and pleasure of such relaxation.

> You will never know who your true Self is until you have experienced complete and ultimate relaxation.

Years later, after my move to the big shop, and living the exhaustion that accompanies a thriving business growing into a larger space, a friend of mine told me about her experience at the Green Valley Spa in southwestern Utah. When she answered "yes" to my wanting to know if it was a white robe type place, I sent for a brochure. I signed up for a week in January, after I hopefully would have lived through yet another Christmas, which in the flower shop runs steadily from the week before Thanksgiving until 2p.m. on Christmas Day.

Southwest Utah itself is a gift of pure, profound, nature-inspired relaxation; the time at the Spa transformed me. It was during that time that I experienced a week free of worries and concerns 24 hours a day for 7 days. I was reprogrammed on a cellular level, an even deeper level of relaxation than I had experienced with Gert at the mountain resort because I picked up the bill myself.

I had to learn to commit myself to self-healing. Before my experience at the Spa I was doing a band-aid approach to sanity maintenance. Sanity maintenance comprises whatever you need to do to keep the madness of running a business at bay. For some it is their weekly tennis game, for another it might be doing the N.Y. Times crossword puzzle, for another it might be the nightly hot bath before bedtime ~ short-term panaceas for the management of daily stress.

Once you know complete relaxation small daily practices can trigger the mind and body to recall that experience.

If you never experience deep relaxation, you can never go to it, because you will not know that you can. Once you've had the real thing ~ true, deep, and profound relaxation ~ there is no going back. The body remembers. So when your brain forgets, ask your body.

Attaining true relaxation is like eating butter for the first time in your life when you've been raised on margarine, or sticking your head in a huge bucket of fresh garden roses when you've only seen silk flowers. True, deep, "no one needs anything of me" relaxation is breathing Rocky Mountain air, not just looking at photos of the peaks. I met wonderful people at the Spa

> *Once you know complete relaxation small daily practices can trigger the mind and body to recall that experience.*

and to my surprise, most of them were working women, like me, who were there to recharge and revitalize. Each one of those women put their sanity and need for relaxation as a priority in their lives. This was a completely new concept for me. I was thrilled to be around such powerful women who knew that in order to impact the world in the ways they were envisioning, they first needed to care for themselves. They were profound role models for me: lawyers, doctors, business owners, writers, teachers, and moms.

I can already hear the sound of distant whining: "A spa is so expensive! I could never spend that kind of money on myself!" HA! As far as I am concerned, a working woman cannot afford NOT to have this experience. Going to the Spa, making the financial and spiritual commitment to my health, was the statement I needed to make to myself that in order for me to give to the world in the big way that I had been giving, and wanted to continue to give, and more, I had to give to myself first.

Some of the life habits I experienced at the Spa I was already following before I went there, but after my visit I realized that without the care and tending of myself in this committed, loving way I would not blossom. And I want to blossom.

I had always perceived myself as such a hard worker, and so sturdy, more like a Pfitzer juniper, one of those never kill, never die varieties. I have come to understand that each human being is a hothouse flower, worthy and deserving of special care and nurturing to blossom into our full potential.

KNOWING MY LIMITS

I wanted so much to be seen as a contributor and someone who could be counted on no matter what. I had so much natural robust energy, and such a strong constitution, and was so unfailingly willful, that I never could see that I needed to be tended or I would burn out, literally that I could, and would, crash and burn if I did not take care of myself on every level.

I did crash and burn ~ physically, mentally, emotionally, and spiritually during my separation and subsequent divorce. It was only then that I had an inkling of my fragility. As I was young, I bounced back. Some years later, well into my business and cruising full speed ahead, I allowed myself to forget my needs to care for myself because I was so busy taking care of everyone else, taking care of business. I forgot that I am, indeed, a hot house flower, and I didn't even realize that I hadn't bloomed for a very long time. Worse than that, I could feel the whole plant getting ready to give up the ghost. I could feel that if I did not commit to my health in a very deep and

profound way I would be heading for a serious fall.

I know entirely too many women who choose the path of sickness to get out of their work madness, like the wolf that bites off his foot to rid himself from the trap in which he is caught. I know women experiencing cancer, major back injuries, viral infections, chronic low-grade exhaustion syndromes, and bouts with migraines ~ the list goes on and on.

You may not consciously choose to be sick, but you unconsciously choose this path by not making the care and maintenance of all parts of you ~ emotional, physical, mental ,and spiritual Health ~ THE priority in your life.

You may not consciously choose to be sick, but you unconsciously choose this path by not making the care and maintenance of all parts of you ~ emotional, physical, mental ,and spiritual Health ~ THE priority in your life.

During the course of running my business I did a lot of trading for massages, rolfing, and any other body work that became available to me. I became totally hooked on the incredible healing that I was experiencing from hands-on healing body work. The thing about massage is that the more you receive it, the more you want it. Like babies, we thrive on warm, caring touch and shrivel without it.

That sacred healing touch is one of the crucial ingredients in creating the environment that nurtures the blossoming of the hothouse plant. Each one of us is a hothouse flower, not just me. We each know that given the right care, feeding, nurturing, and environmental conditions, we will thrive.

If you do not make the caring and feeding of YOU your priority, who will? What is the price of your sanity? In my way of thinking, there is

nothing that would get in the way of caring for me. There is no way that I can impact my world in a positive way if I am unwell. If I give myself the care and tending that I need then I am in my top form to give of myself in the best possible way.

Look at our deified athletes and movie stars. They completely nurture themselves so that they can give the best performances to us. The healthy ones are good role models for us to care for ourselves. They uplift us with their splendor, but they are each one of us as we can be in our splendor when we make our healing and self-care our number one priority.

> *If you do not make the caring and feeding of YOU your priority, who will ?*

You can't fight your body; you have to work with it. Do what your body tells you it needs ~ it is much smarter than your brain. If you can't hear what your body is telling you, you are not listening well enough, you are not giving yourself enough down-time to be able to hear what your body has to say.

The daily life that we create for ourselves IS our Life. That is all there is. Either you are creating a life for yourself that works, or you are not. One of the first and easiest places in your life that you can make change is in the daily caring of yourself, be it from the simplest thing as a hot bath in a candlelit bathroom before you go to bed each night to a rigorous exercise regimen. However, you choose to honor yourself will show itself in your mental and physical health.

Think of your car. You would never want to crack your engine block on a cross-country trip, but if you never checked the oil level and you never added oil to the engine when it was needed (that's actually before it is empty), then you did create the engine block crack by not consciously tending to your vehicle. Your body-mind-spirit is your vehicle that lovingly transports you through your life. If you do not consciously care for it, you will crack

its engine, no doubt about it. I see this as the most important form of insurance that I can buy for myself. It's like taking proper care and maintenance of my car. The more diligent I am about maintaining my car, the less likely I am to have overwhelming, not to mention expensive, repairs with which to deal.

You can't fight your body; you have to work with it. Do what your body tells you need to do ~ it is much smarter than your brain. If you can't hear what your body is telling you, you are not listening well enough, you are not giving yourself enough down-time to be able to hear what your body has to say.

Of course with your body, you are looking at a much more complex system of systems, all of which need to be cared for and maintained in a conscious way, or you are heading for system failure. How infinitely more difficult it is to treat an ulcer than a leaky fuel pump.

Every time you give yourself one of the endless reasons why you cannot possibly create relaxation time in your life, think again. Prioritize your time to include precious time for self-care. Then you'll never have to fix your own cracked block. I hear that sometimes you can go too far and too long without caring for yourself and there is no returning to feeling good. It is lost forever. Choose to feel good so you can be the person you dream yourself to be in your world, in your way.

A FAREWELL MESSAGE FROM A BRILLIANT WOMAN

Sitting at the bedside of my dear friend, releasing from Life in the last stages of cancer, I was moved by the expression of regret she offered up upon re-

viewing her life. She said, "I wish I had given to myself some of what I gave to everyone else. I wished I had cared better for myself and given myself what I really needed, if I had only known what that was. I never primped, I never pampered my-self. I never treated myself as a woman worthy of caring for and look at me now.

Prioritize your time to include precious time for self-care.

I should have had massages and manicures and pedicures and vacations that were just for me. I am sad that all this loving and caring showered upon me now I can finally accept because it is my deathbed. What a waste."

Thank you for those words of wisdom at the end of a life in serving others, but never serving oneself. I am moved by her acknowledgement that she led a life out of balance. Her words inspire me to live my own life in a more balanced, conscious way, tending to my own needs before I think I can tend to someone else's.

At the end of my days, which might be today, I want to look at my life and say, "I treated myself as well as I treated others. I handled my life well." I can only say this if I step up to the plate and take full responsibility to create the life I want for myself, by making choices that uplift and support me as a spirit so I can go out in my world and uplift and support others. The choice to make true and real relaxation for myself is the number one important choice I make for myself every day to feed my spirit and help it to blossom.

PRIESTESS PEARL OF WISDOM

Giving yourself the gift of deep, profound relaxation is the key to creating and maintaining a healthy balanced life for yourself. As a businesswoman Priestess Entrepreneur the daily stress of Life's demands can take center stage if you do not commit 100% to caring for yourself as your number one priority.

The important aspect of any revitalization, regenerating commitment is that everything is done for you so that you do not have to tend to even your smallest need. You need to have the experience of being totally and completely cared for so your mind is relaxed and open to messages from your True self, unencumbered by any one else's input and the endless details of self-maintenance.

Once your mind, body, and spirit have experienced that level of caring for yourself you may return to that place inside of yourself, triggering those deep relaxation states by daily reminder practices. Since the body holds memories of its experiences, when you trigger the body with relaxation cues, like a hot scented bath in a candlelit room, you can access the relaxation your body holds in memory for you.

Reprioritizing for relaxation helps us to be happier, more balanced women. Happy, balanced women make for the ability to make happy, balanced business decisions which make for happy, balanced businesses.

CHAPTER 14

When You Know You've
Had Enough ~
MOVE ON, MOMMA

Fourteen

At a professional women's gathering the other evening we were asked to share what we had done in our lives that felt like the biggest risk we had taken professionally. In that moment I realized that the biggest risk I had taken, though at first thought might be that I had opened a flower shop, was actually that I chose to sell it. I had been so identified as "the flower lady" that I was not sure that I would be able to recreate myself and my professional identity to be anything other than that.

Though the thought of recreating myself was terrifying, the thought of remaining a shop owner was even more so. My exhaustion level was so extreme that it overrode my fear. And that is no exaggeration.

Entrepreneurs are big risk-takers. It is inherent in our natures. Priestess Entrepreneurs know when they are finished serving in one arena, they need to consider where next their gifts are needed. It takes just as much risk, if not more, to trust yourself and walk away from what no longer serves you as it took to start your business in the first place.

Remember that when you started your business you had to walk away from something else. When you let go of whatever business you are doing now you are not only closing that door, you are opening a new door to your next life experience. Sometimes you know exactly what you are moving on to next in your life. Sometimes you need down time to re-incubate your next move.

Each person moves on in her own unique way, just as every person

begins a venture her unique way. The important thing is to be true to you. Everyone, to a person, asked what I would do with myself after the shop. I did not know. I had not a clue. All I knew was that I needed to sleep for at least a year. I got so tired of people asking me of my plans. I realized they were projecting their own fears of what they would do if they no longer did their jobs. I told people I was becoming an astronaut. What I didn't tell them was that I'd be astral traveling from a prone position on my bed or couch, during my recuperation from retail.

ALWAYS, ALWAYS LISTEN TO YOUR OWN INNER VOICE

Inside each one of us is the voice of our own truth. I have spoken of that inner voice frequently throughout this book for it is the voice that speaks to you of your life journey. When it is time for you to move on from your business, that voice will begin as a whisper and then, if you don't pay attention, it will build to a bellow before too long.

The voice often speaks through the body. When the voice speaks through the body, we cannot help but listen. If you do not pay attention to the voice the body creates pain or chronic discomfort. The voice is brilliant, it is your divine spark,

> It takes just as much risk, if not more, to trust yourself and walk away from what no longer serves you as it took to start your business in the first place.

and it will do what needs to be done to get your attention. Pain speaks loudly and gets our attention. Pain can show up physically, but it may show up emotionally as well.

I was so physically tired from the work of the shop that I started to develop intense back pain. Over time, the pain debilitated me. Though I

received bodywork and took good care of my physical body through yoga, swimming, and walking, the pain was not physically based, it was stemming from my inner voice. The inner voice was trying to get my attention, telling me it was time to let go and move on.

When the voice manifests emotionally you might feel overly depressed or, conversely, overly agitated. Anne, another retail shop owner, had so much anxiety over her business, knowing she needed to move on but could not let go, manifested her anxiety as grinding her teeth at night, which caused her to experience acute, turning to chronic, TMJ.

I became intolerably irritable (as I have been told) because no matter how much I slept I was still exhausted. I went to sleep thinking about the shop; I awoke thinking of the shop. I lived and breathed the shop. I could no longer tolerate the level of commitment that the shop required of me. My body was telling me so, physically and emotionally.

Letting go and moving along our life journey can be very difficult. We get so attached to our ideas of who we are and what we have created ourselves to be. To be able to listen clearly to the *Ask support from other women who have moved on in their life careers.* inner voice of movement does not come easily or naturally in our cultural context. Our culture teaches us to hold on to what we have and to stay with things no matter what the consequences. The more you can filter out the dominant culture's messages and truly listen to the voice of your own reason and sanity, the more you will able to discern if moving on would serve your higher purpose more than holding on for dear life would.

Ask support from other women who have moved on in their life careers. You know how sometimes in your life you overhear something that is being said to someone else, you hear it, and years later you recall it and realize it was meant for you?

I was passing through the lobby area of the Human Development School at Cornell University during my first semester there, where I overheard an interesting looking women in her late sixties telling a young woman student how proud she was at how many different jobs and careers she had had so far in her life. She was talking about how unimportant it was to think that, as a freshman, you could possibly know what you'd like to do with THE REST OF YOUR LIFE! Who could possibly know that? She told this young woman how she herself had tried anything and everything that came her way if it called her to do so. She said that the true success of a person was not in being accomplished in one field of study, but being able to look back on one's life and say "I tried everything that I wanted to... I did it all!" She said if you don't like something you find yourself doing, let it go, and move on to something else.

This was good for me to hear, at that time and at many other life junctures in the years that were to come. At that time, in my freshman year at college, I was registered in the Human Resources school, thinking that I would be studying psychology and human services. Even though I came back to this field years later, at that time it was what I thought I should want, when in reality I didn't enjoy the courses at all. My personality is such that when I feel that I cannot tolerate something I want to get out of it immediately, if not sooner. I needed to figure out something for the Spring semester, and fast. This was October. I probably had one week to change majors, and schools. I did not think I could make it a year in that program. One of the main reasons that I could afford to attend Cornell was that as a New York State resident I could attend a few of the schools at Cornell for the fee of attending a State university. I could be on the Cornell campus, take courses at any school there and still graduate from, and pay tuition of the state schools. Therefore if I transferred out of the Human Resources school I needed to go to one of the other state division schools there at Cornell. Because I am such a Pollyanna type, as my sister calls me, always believing that the absolutely right thing will be there for me if I look, I

completely believed that I would find the right thing for me.

Of course I was terrified of what my parents would say and would I even be able to pull this off? I came from a family that was big on following through on what you started. I wanted very much to be at college but I knew I would not be able to tolerate the program for which I had signed on.

The next day I picked up a few catalogs at the admissions office. I was flipping through the catalogue for the school of Agriculture and Life Sciences and, to my utter shock and disbelief, I found an entire major in Floriculture and Ornamental Horticulture… FLOWERS!! I could hardly believe my luck. A person could actually major in flowers??!! I was in. I was beside myself with joy. I changed majors and spent the next three and a half years in blissful heaven, in classes about every-

Begin to make changes. The more you do it the easier it gets.

thing I love. It was such an important thing for me to walk away from what I thought I wanted, only to find something I could only have dreamt of in my best of dreams. I learned if you don't like how something is in your life – change it. Let it go. Move on down the road.

I also moved from the snooty north end of campus to the way groovier west campus, where my social life flourished and my new friends at the Ag school lived and hung out. What excellent decisions ~ and all in that first year. It sounds like nothing now so many years later, having made so many huge life-changing decisions like marriage, divorce, business beginning, business ending, graduate school, and cross-country moves, but it was the beginning.

Begin to make changes. The more you do it the easier it gets.

LETTING GO GETS EASIER THE MORE YOU DO IT

Each time you make a life change, surrendering to the guidance of your inner voice and allowing yourself to evolve and grow, it gets easier.

Letting go is like a muscle, you have to use it or you lose the capacity to enjoy its gifts.

All one's life changes start with the very first one. As soon as I left home and my parents' way of doing things, as soon as I took my life in my own hands, for better or for worse, I was making changes. As I moved along in my life, though the changes I undertook were larger in reality, in my mind they paled in comparison to the first ones. The more I used my change muscles, the more flexible I became, the more confident I became, and the more I learned to trust my inner voice to direct me well.

During my seventh year in the shop I got clear in my mind that I had to move on from my business. Once I could honestly admit that I had had enough, I knew I had learned all that I could learn in that experience. I had gone as far as I could with the business and I absolutely had to let it go, to sell it.

It took me three years to sell it.

My desire was to sell the business with enough left over after paying my debts to give me a little cushion, time to digest my experiences and to reflect on where I would go next, what I would next create.

And that's exactly what I did.

PRIESTESS PEARL OF WISDOM

Change is inevitable. Resistance to change is not. Reach out for support and encouragement when your inner voice whispers to you that the winds of change are upon you and it is time to breeze into the next phase of your life.

The more clearly you can listen to and respond to that which is true and real for you, the more joyously you live your own life. As each of us commits to living what is true and right and fulfilling for ourselves, we commit to creating a better world. When we live in truth we live in freedom.

It is my heartfelt dream to see each of us living the truth of our own divine spark, the spark that is nurtured from embers into flames by the Priestess energy of knowing our true selves. To this dream I commit myself. This commitment is the gift I was given when I let go of my business and stepped into the next part of my journey. I hope in some small way my journey inspires yours, that you step into, and glory in, your own conscious empowerment, that you embrace the essence of the Priestess Entrepreneur, living your divinely inspired life.

Printed in the United States
59218LVS00006B/247-288